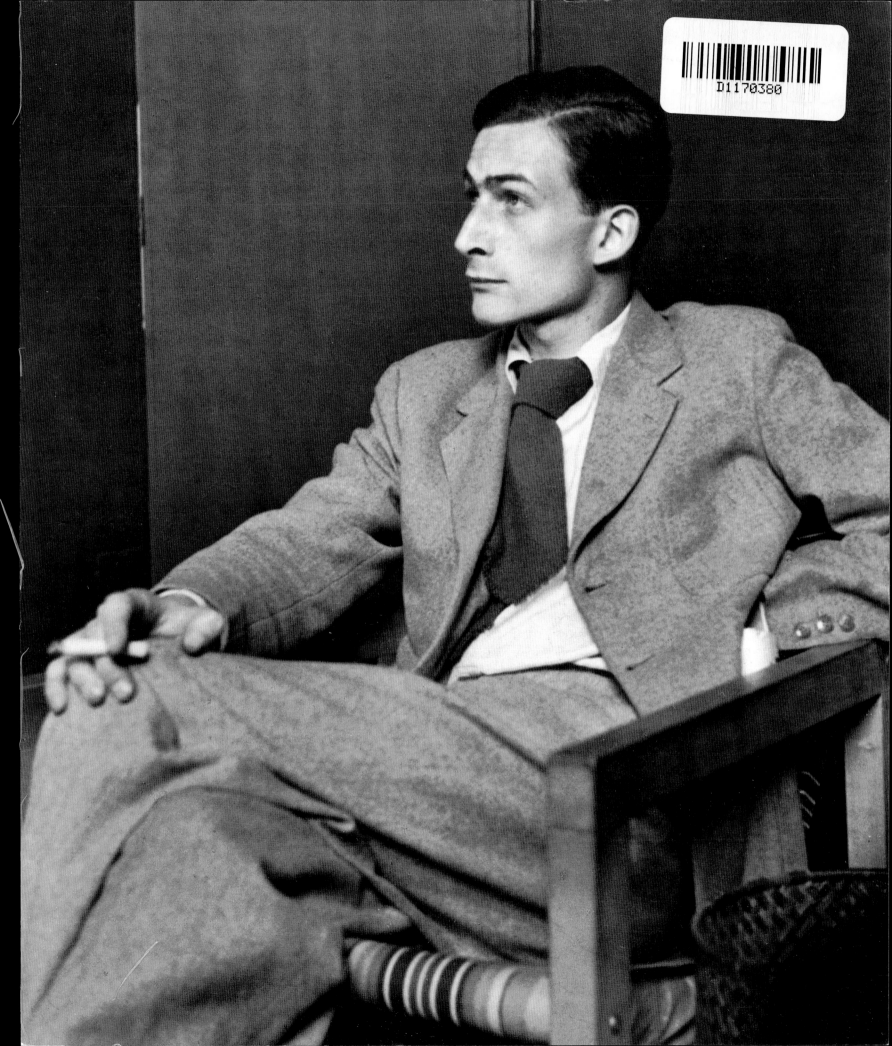

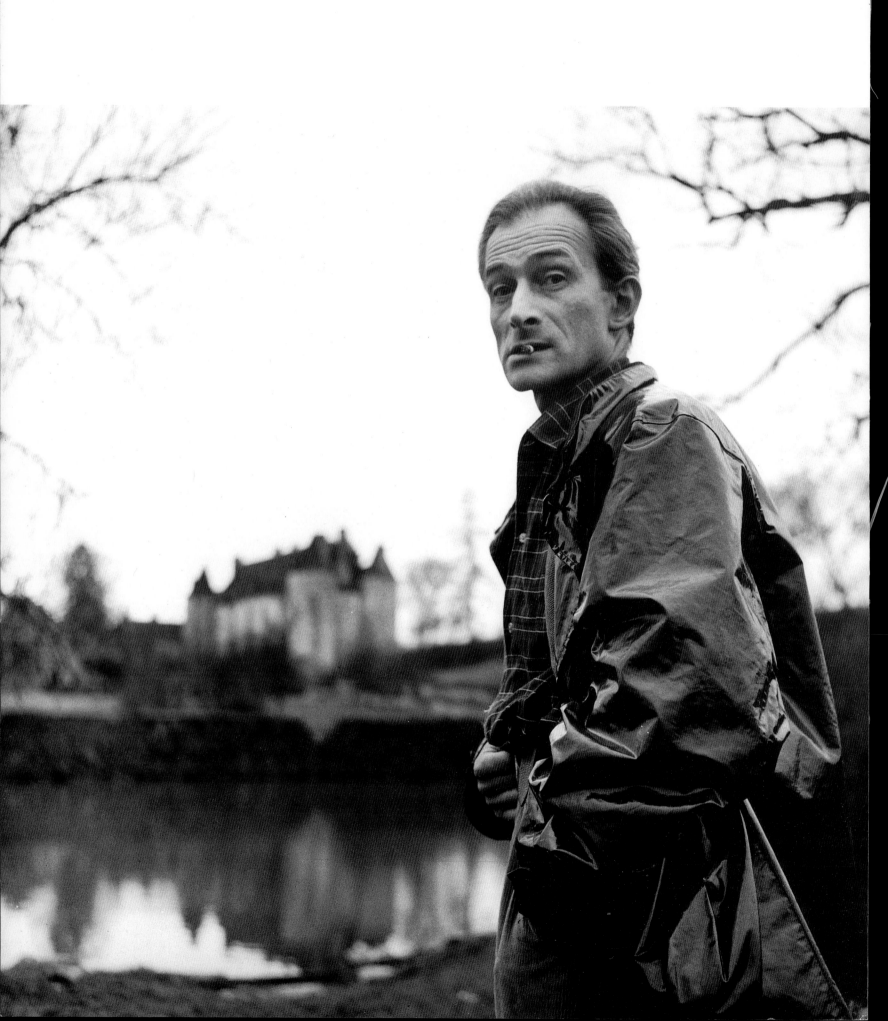

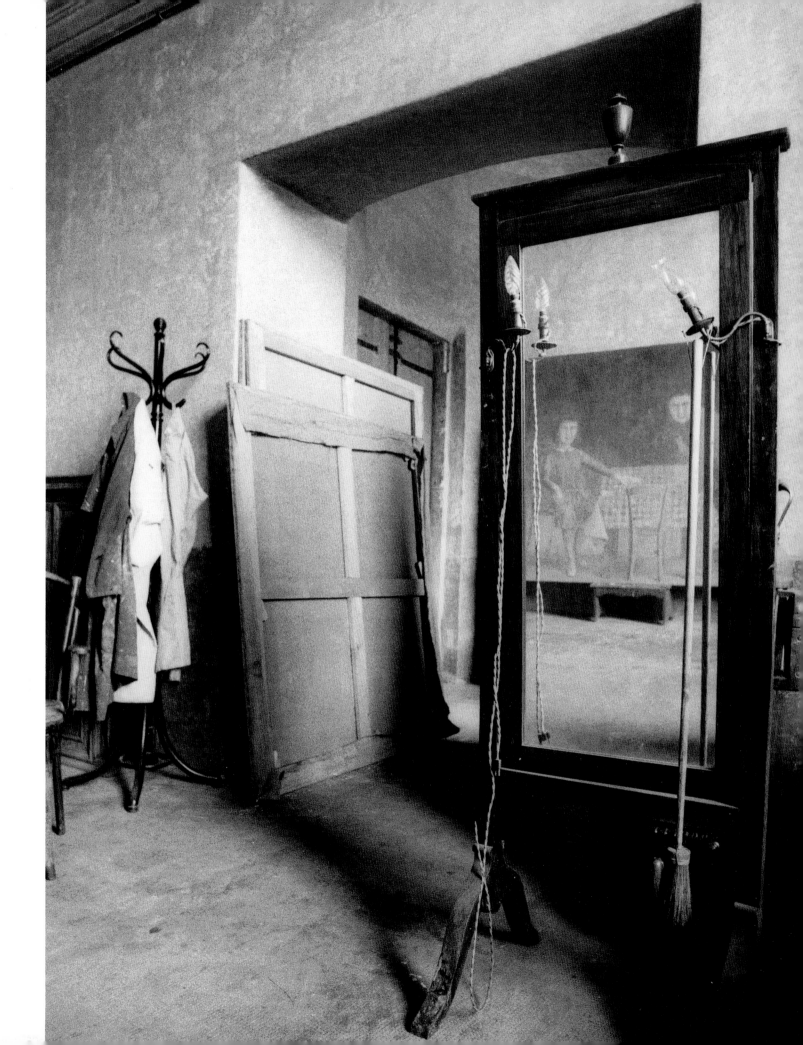

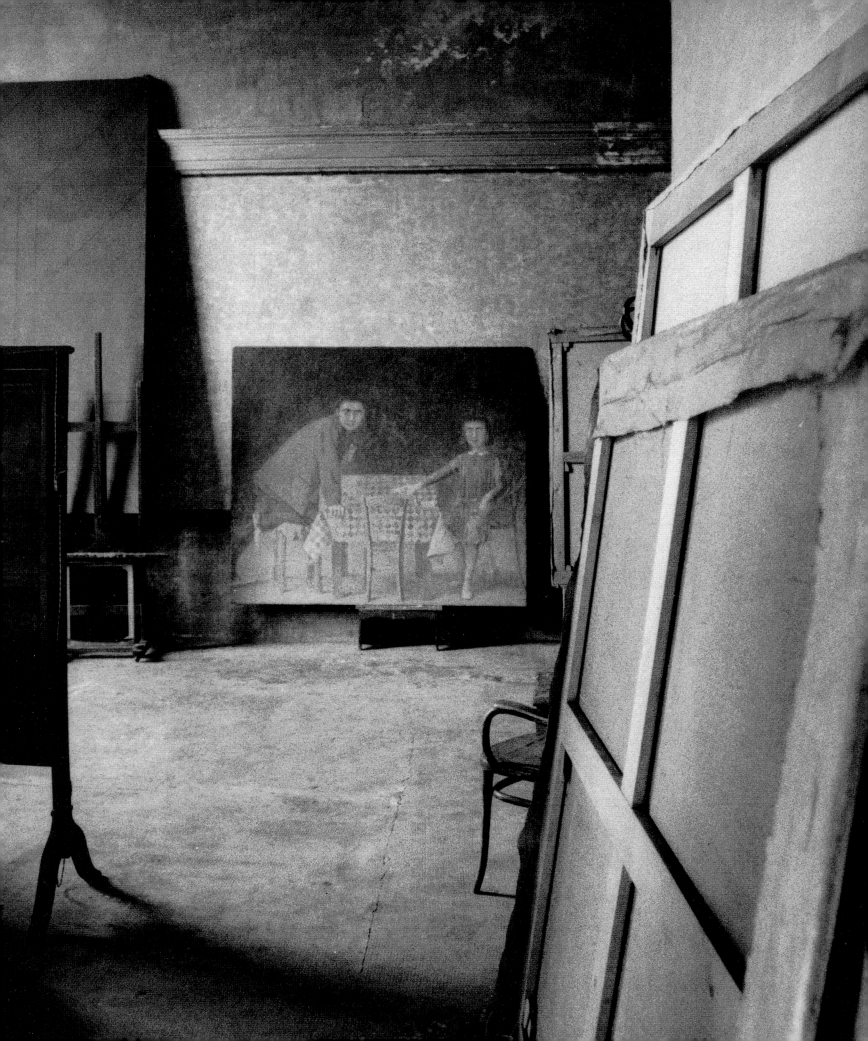

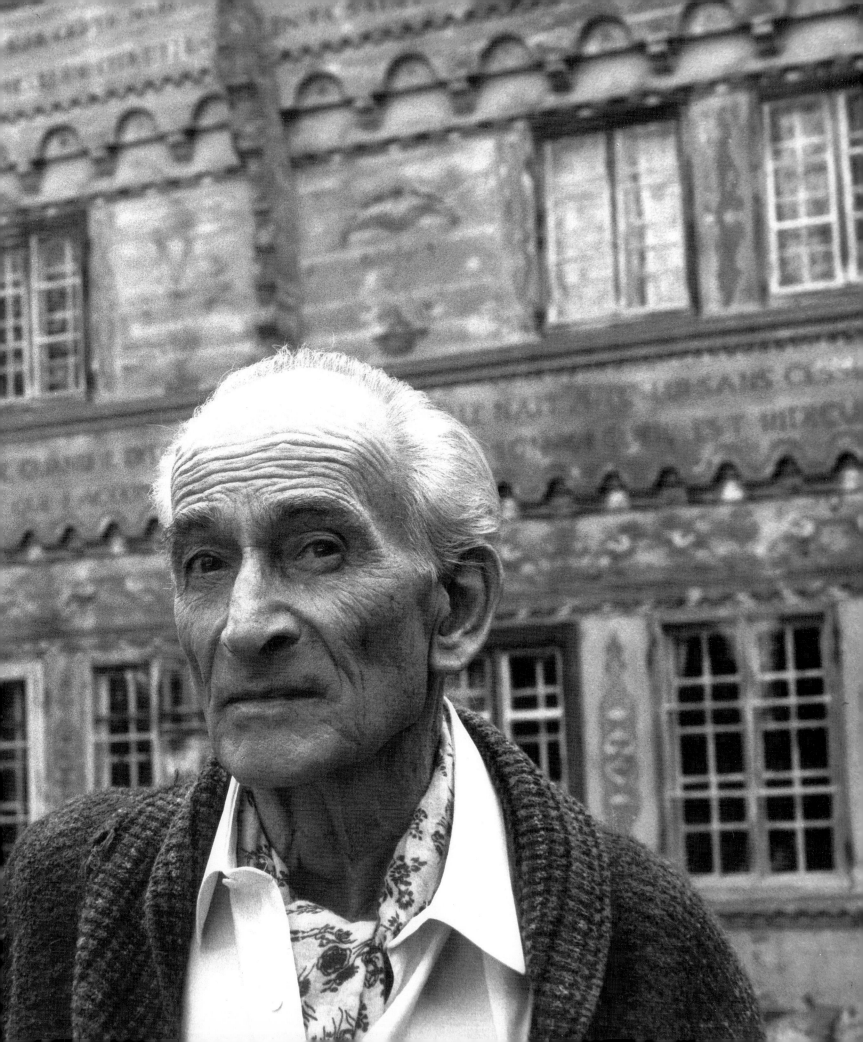

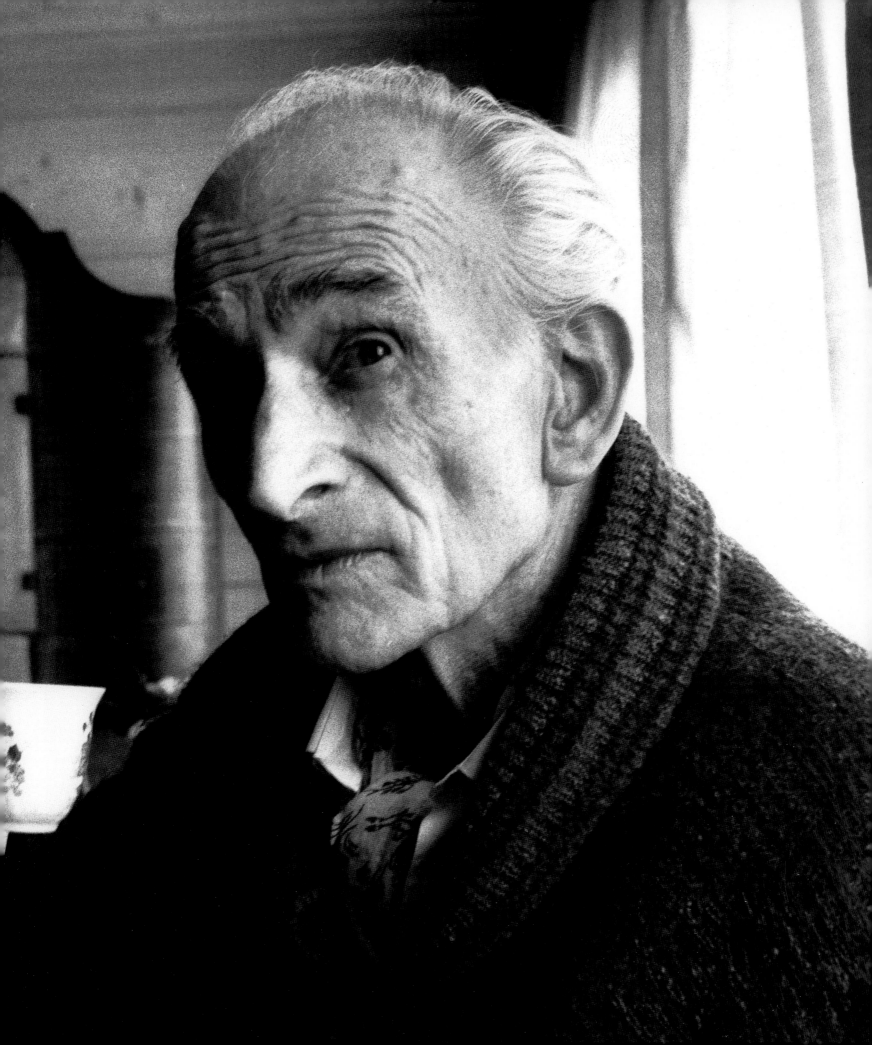

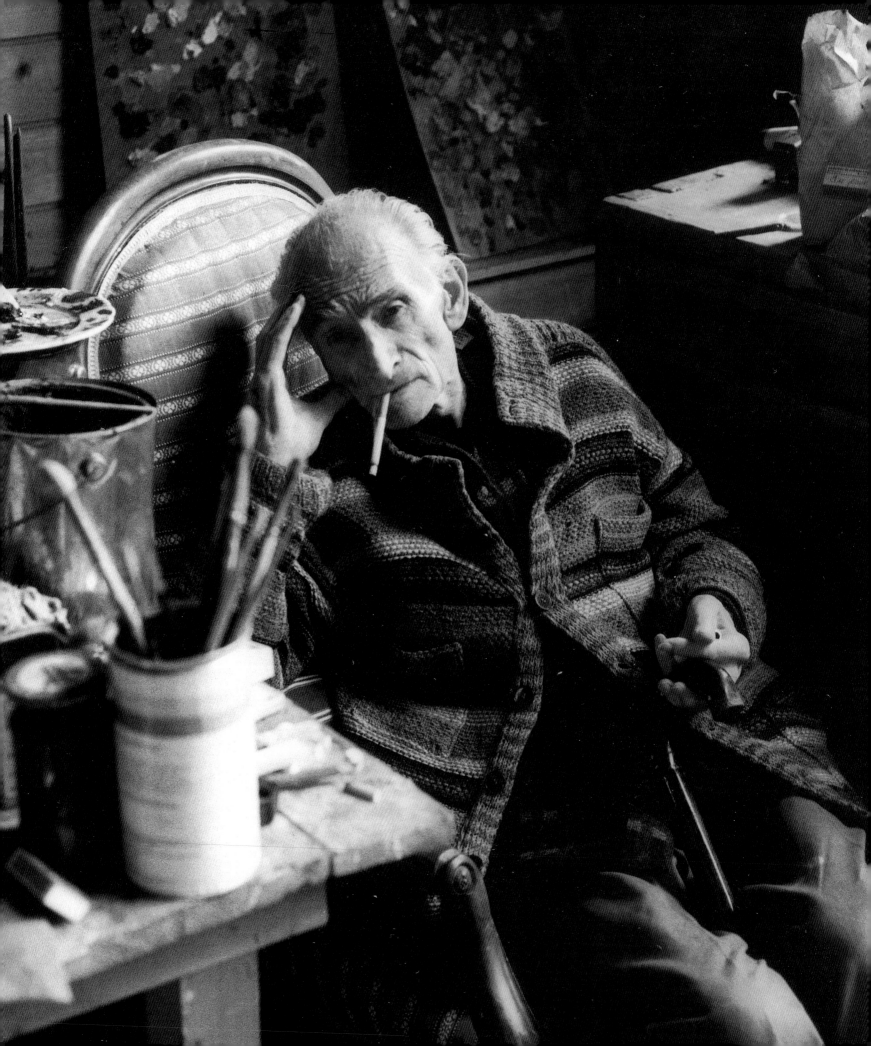

BALTHUS

BALT

Expanded edition

Stanislas Klossowski de Rola

THUS

HARRY N. ABRAMS, INC., PUBLISHERS

ACKNOWLEDGMENTS

The publishers most gratefully acknowledge the help and assistance of the Balthus Foundation. In addition, the author and the publishers would like to express their gratitude to the late Pierre Matisse, the late Henriette Gomes and to His Grace the Duke of Beaufort for their help in gathering photographic material for the first version of this book. We would also like to thank the private individuals who have allowed their works to be photographed for this book and the institutions that have supplied us with transparencies. We are indebted first and foremost to Countess Setsuko Klossowska de Rola. We would also like to thank Thomas Fay, Martin Summers and The Lefevre Gallery, Madame Virginie Monnier and Madame Bernard Hahnloser for their generous and invaluable contributions.

Library of Congress Cataloging-in-Publication Data

Klossowski de Rola, Stanislas
 Balthus / Stanislas Klossowski de Rola
 p. cm.
ISBN 0-8109-3134-6 (clothbound)
1. Balthus, 1908– –Catalogs. I. Title.
ND553.B23A4 1996
759.4—dc20 96-14108

ISBN 0-8109-2119-7 (paperback)

Expanded edition 2002

Copyright © 1996 and 2001 Thames & Hudson Ltd, London
Artistic works copyright © Estate of Balthus Klossowski de Rola

Published in the United Kingdom in 1996 and 2001 by
Thames & Hudson Ltd, London

Expanded paperback edition published in 2002 by Harry N. Abrams,
Incorporated, New York
All rights reserved. No part of the contents of this book may
be reproducedwithout the written permission of the publisher.

Clothbound edition published in 1996 by Harry N. Abrams, Inc.

Printed and bound in Italy
10 9 8 7 6 5 4 3 2 1

 Harry N. Abrams, Inc.
100 Fifth Avenue
New York, N.Y. 10011
www.abramsbooks.com

Abrams is a subsidiary of

CONTENTS

INTRODUCTION

L'artiste reproche tout d'abord à la critique de ne pouvoir rien enseigner au bourgeois, qui ne veut ni peindre ni rimer, — ni à l'art, puisque c'est de ses entrailles que la critique est sortie. Et pourtant que d'artistes de ce temps-ci doivent à elle seule leur pauvre renommée! C'est peut-être là le vrai reproche à lui faire.

Charles Baudelaire

On 18 February 2001 my father's earthly life came to an end. He was finally delivered from all the pains and indignities he had had to endure as old age and increasing ill-health had exacted an ever greater toll, robbing him in the process of what he prized the most: his time in his beloved studio.

To the very end he refused to accept the inevitable, never losing confidence that he would eventually recover and resume work, quite convinced that he would be granted a stay to complete his ambitious plans. On his last night, he asked to be transported to his studio and, although in great pain, spent several hours planning the finishing touches to his last painting, which he had tentatively called *L'Attente* (*The Waiting*). When he was finally borne back to his rooms he had only four more hours to live.

With his passing the world lost a great painter of unflinching integrity, while I lost a much cherished father whose vast and profound culture had acquainted him with the most recondite subjects and authors which we both loved to discuss.

I publicly salute my stepmother Setsuko, whose love, unwavering devotion, vigilance and extraordinary patience allowed him to survive many a close call and to carry on working. She is the guiding spirit of the Balthus Foundation and in several apparently hopeless instances has proven able to make the impossible come true.

In 1983, when I wrote the introduction to the first edition of this book, my father's conviction that biographical details about a painter were not essential for the study of his art remained staunch. He objected to the wordiness of art books and told me that a book about his work should be a book of pictures, not a book of words about pictures.

At that time, Balthus was extremely reluctant to speak to reporters, he had refused all invitations to appear on television, and had not allowed anyone to photograph him

for years. His phobia of being photographed extended to his intimate sphere and rare were the snapshots 'stolen' in our family circle. On one occasion, I visited from America bearing one of the first SX70 Polaroid cameras. This intrigued him so much that we posed, heads touching, while I held the camera at arm's length and took the first shot that I had ever had of the two of us together.

In recent years, however, in an extraordinary volte-face, Balthus consented to countless interviews. He was the subject of several television documentaries, and was photographed innumerable times. Nevertheless, he still expressed considerable disappointment with most of what was written about him, which was all too often characterized by a combination of misunderstanding and sheer nonsense. Despite the apparent paradox of his somewhat arbitrary concessions to the claims of worldwide fame, Balthus remained as firmly convinced as ever that his paintings should be seen, not read about, or read into. After pressing Balthus for biographical details while preparing his text for the 1968 retrospective at the Tate Gallery in London, the English art critic John Russell received the following telegram:

NO BIOGRAPHICAL DETAILS. BEGIN: BALTHUS
IS A PAINTER OF WHOM NOTHING IS KNOWN.
NOW LET US LOOK AT THE PICTURES.
REGARDS. B.

Needless to say, art critics and art historians for the most part feel otherwise. They have pounced upon and dissected every available shred of biographical information in a misguided search for clues regarding his work. They have, at times, traced to outlandish sources the lineage of a composition and speculated recklessly on the

predicaments they believed the subjects of a given painting to be in. Such unbridled flights of fancy are laughable (and we did laugh a great deal, for my father had a great sense of humour) but they do not contribute anything to the true appreciation of art. The philosopher A.K. Coomaraswamy (whom Balthus called 'my spokesman') warns that they: '…must not be confused with a psycho-analysis of our likes and dislikes dignified by the name "aesthetic reactions"…. The study of art, if it is to have any cultural value, will demand two far more difficult operations than this, in the first place an understanding and acceptance of the whole point of view from which the necessity for the work arose, and in the second place a bringing to life in ourselves of the form in which the artist conceived the work and by which he judged it. The student of the art must be able to elevate his own levels of reference from those of observation to that of the vision of ideal forms. He must rather love than be curious about the subject of his study.'

The distinction between merely looking and really seeing what one is looking at seems trite, but it is one of the tragedies of modern culture that this capital nuance has been lost. One's eye, constantly distracted by the multiple solicitations of daily life, succumbs to what my father called a kind of inertia, causing a failure to see properly. Visiting exhibitions has become a component of cultural snobbery: one reads notices, one looks, one reacts, one likes, one dislikes – but at the end of the day what has one truly seen?

For my own part, I would advocate an elevation of concentration to a form of contemplation devoid of intellectual notions, wherein the seer, the act of seeing, and the seen become one. Balthus, in his daily celebration of Beauty, followed the inner prompting of a mysterious tradition whose secret and sacred tenets he was constantly

in the process of rediscovering. Painting, which he always compared to praying, was for him the vehicle of an all-encompassing Inner Reality propelling him forward on an unknown path, a mystical journey of rediscovery and recognition.

From early childhood, Fate appeared to steer him in that very direction: he picked up a book on Chinese art and to his amazement he found therein the reflection of his own vision. In 1922 my grandmother's friend, the poet Rainer Maria Rilke, marvelled at 'this boy so strangely oriented towards the East…. When we went to see him at Beatenberg in September, he was just painting Chinese lanterns, with a flair for the oriental world of form that is amazing. Then we read the little Book of Tea: one cannot imagine where he gets all his assured knowledge of Chinese Imperial and artistic dynasties….'

By the age of twelve Balthus had completed *Mitsou*, a book of forty drawings which Rilke prefaced in French and caused to be published in 1921. Yet despite such a promising start his artistic progress was far from easy. He wanted to study art but the painter Bonnard, another friend of my grandparents, advised against it. Thus Balthus acquired the rudiments of his craft by copying old masters: Poussin and Chardin at the Louvre, Piero della Francesca and Masaccio in Italy, and the Swiss eighteenth-century portraitist Joseph Reinhardt in Bern.

On 26 June 1926, six months before his death, Rilke wrote to Balthus about the now lost copy of Poussin's *Narcissus*: 'My friend, do not leave without sending me your Poussin (mine: I say with pride). It would seem as if my very walls had changed their clothes to receive it in a worthy manner: it will probably be their only decoration; the room has become so very pretty this time, with those green panels of my own invention….'

My father always deplored the loss of the basic craft of painting, whose skills, techniques and secrets could in former times be acquired in a master's studio. He would often describe as hopeless his desperate quest for the elusive mastery of his craft, complaining that he had had to teach himself everything by trial and error. He was, he said, like a man trying to write a novel in an unknown language.

The first faltering steps in his artistic evolution were driven by what he described as the need to capture reality at all costs. As he pointed out to me, in his earlier work, the means he employed in his search for greater realism were more akin to drawing than to painting. Then, as his vision evolved, seeds of doubt began to sprout, and Balthus felt the very nature of the seen escaping him more and more. Such an exacting tribute had to be repeatedly paid to ripening vision and experience before the fruits of his labour could be rewarded by that crowning mysterious transfusion that Braque called *'le fait pictural'* (the pictorial fact) – the point at which a painting becomes a picture and can no longer be improved upon.

In his last works (which took longer and longer to complete) he built layer upon layer of glazes and contrasting hues of incredible subtlety. From the extraordinary texture of those canvases emanates a strange hieratic intensity. According to Hermes Trismegistus in the *Asclepius*: 'He who preserves and adds to the world's Beauty by his love, joins his own work unto God's Will…will be blessed by being restored pure and holy to the nature of his higher self which is Divine.' Towards that truly religious goal, Balthus, amused but never distracted by the games of fame, steered his course till the end.

PLATES

Author's note
No 'story-telling' element should be derived from the works' titles, which have been given only for the purpose of identification and rarely by Balthus himself.

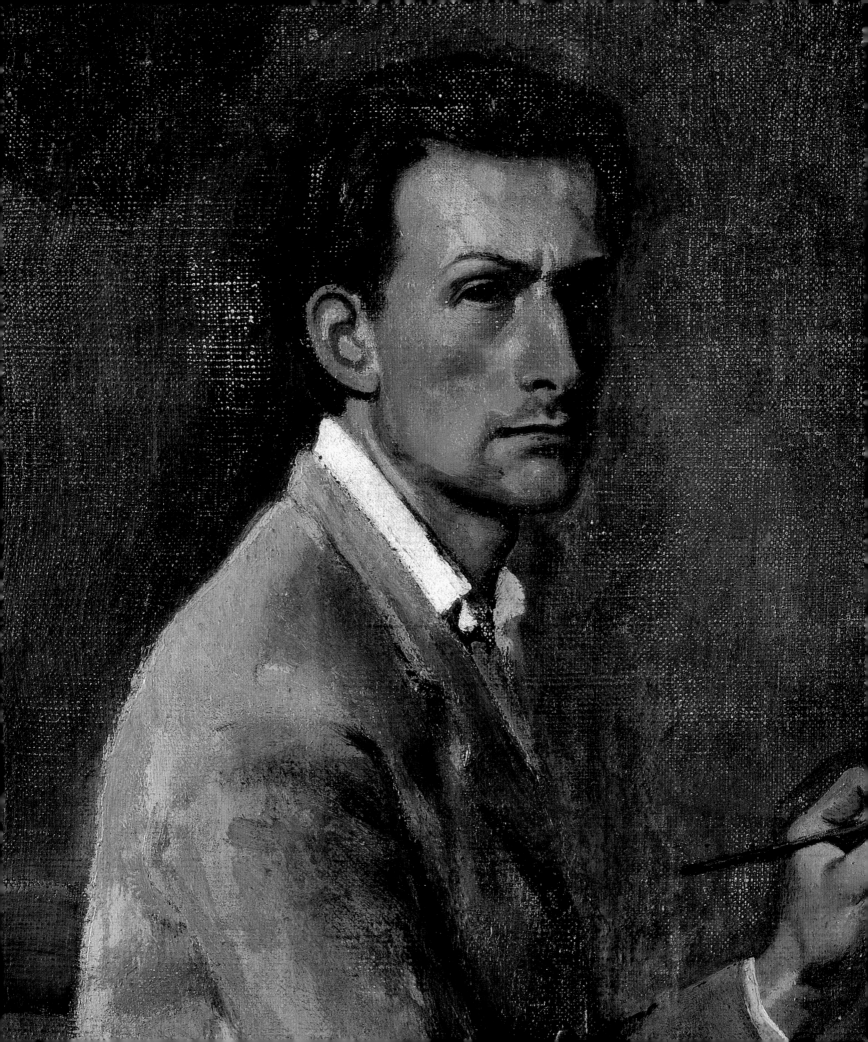

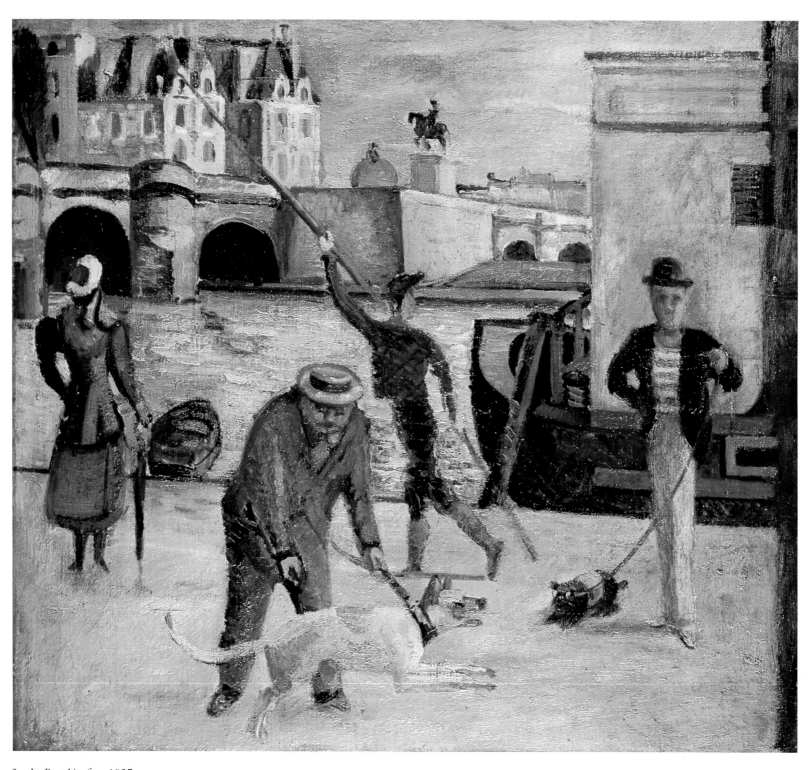

2 *Le Pont Neuf* c. 1927

<1 *Autoportrait* 1940

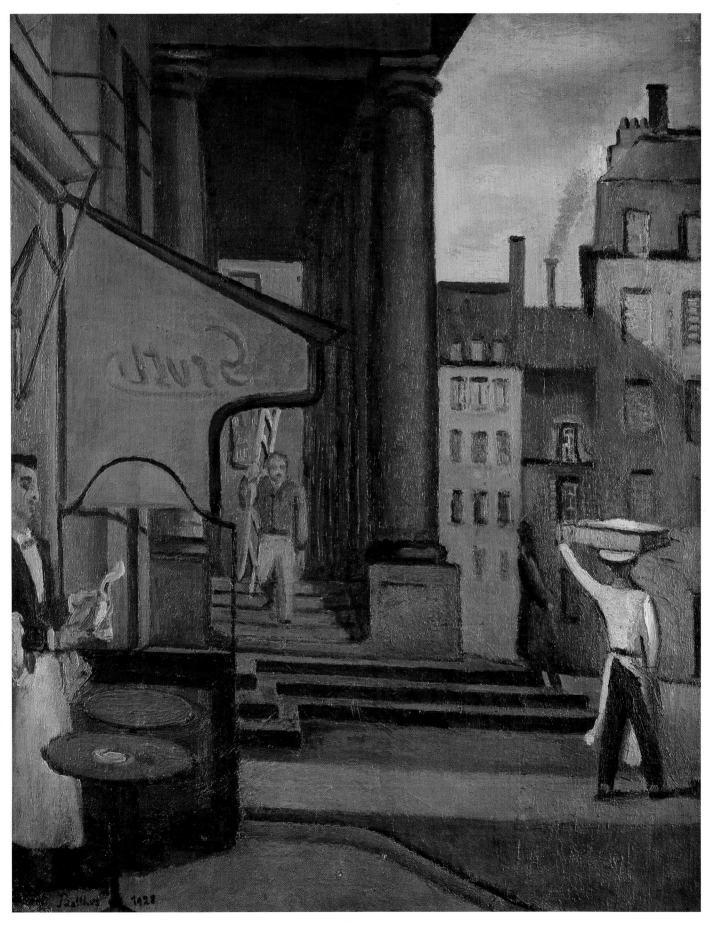

3 *Café de l'Odéon* 1928

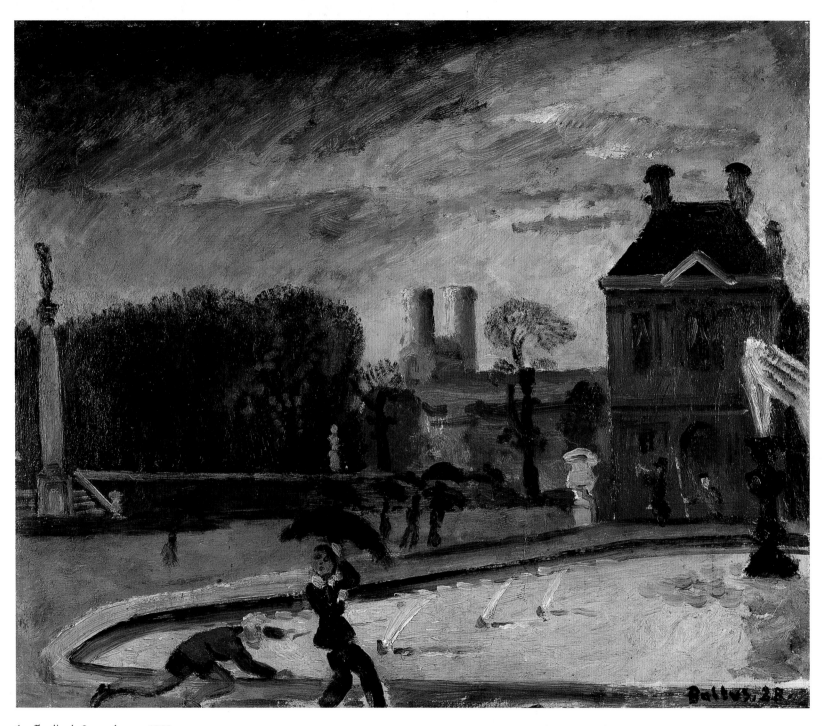

4 *Jardin du Luxembourg* 1928

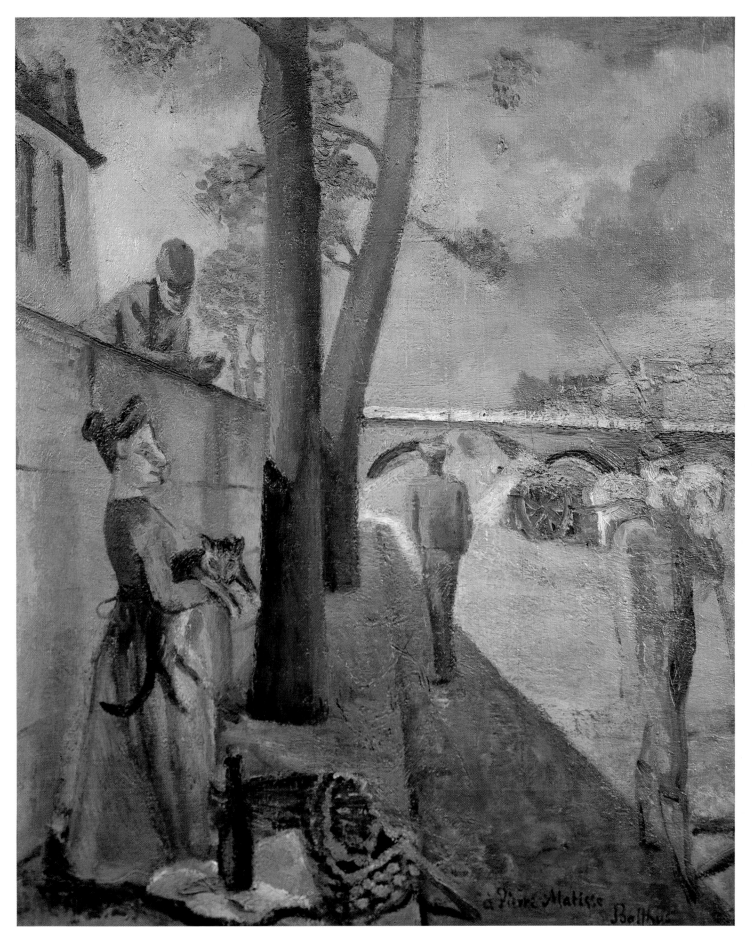

5 *Les quais* 1929

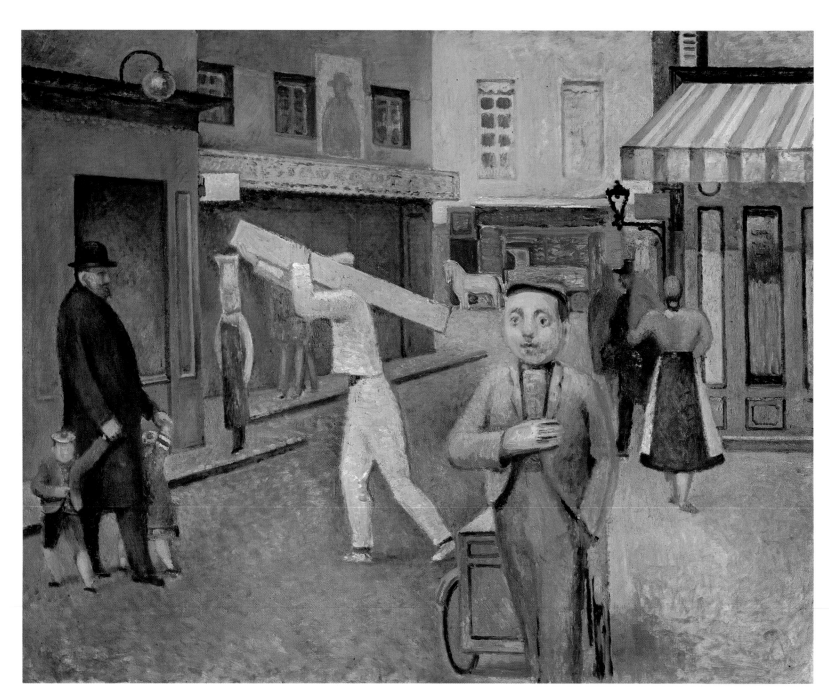

6 *La rue* 1929

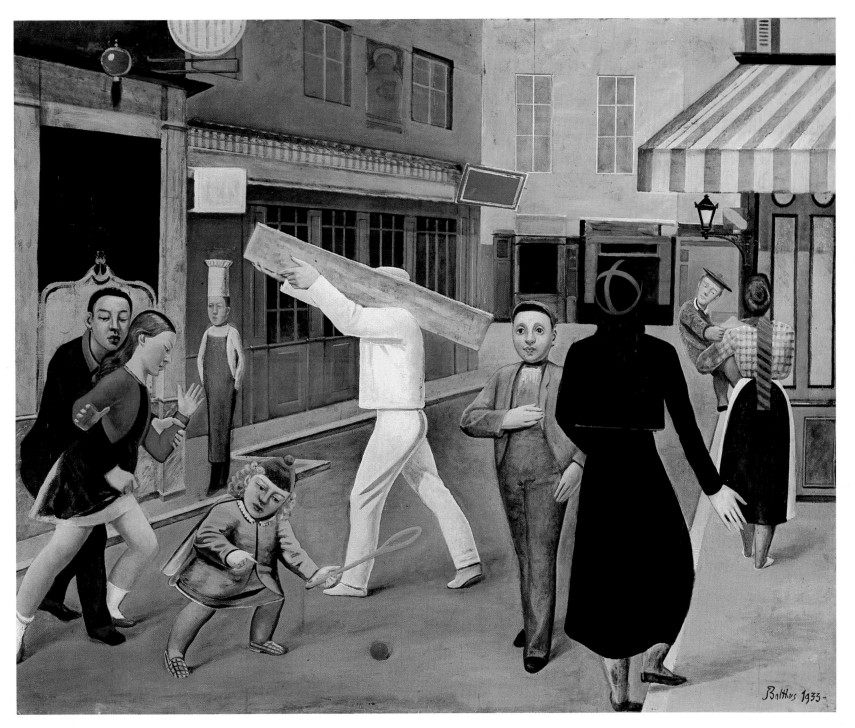

7–9 *La rue* 1933–35

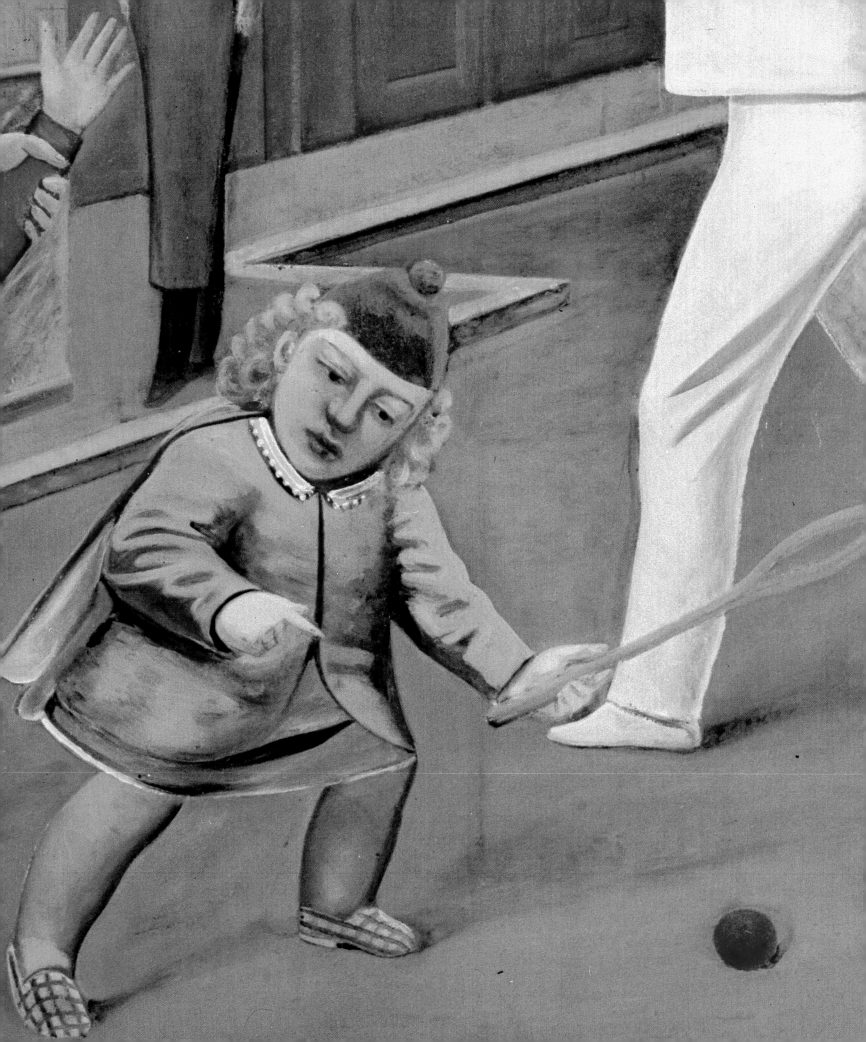

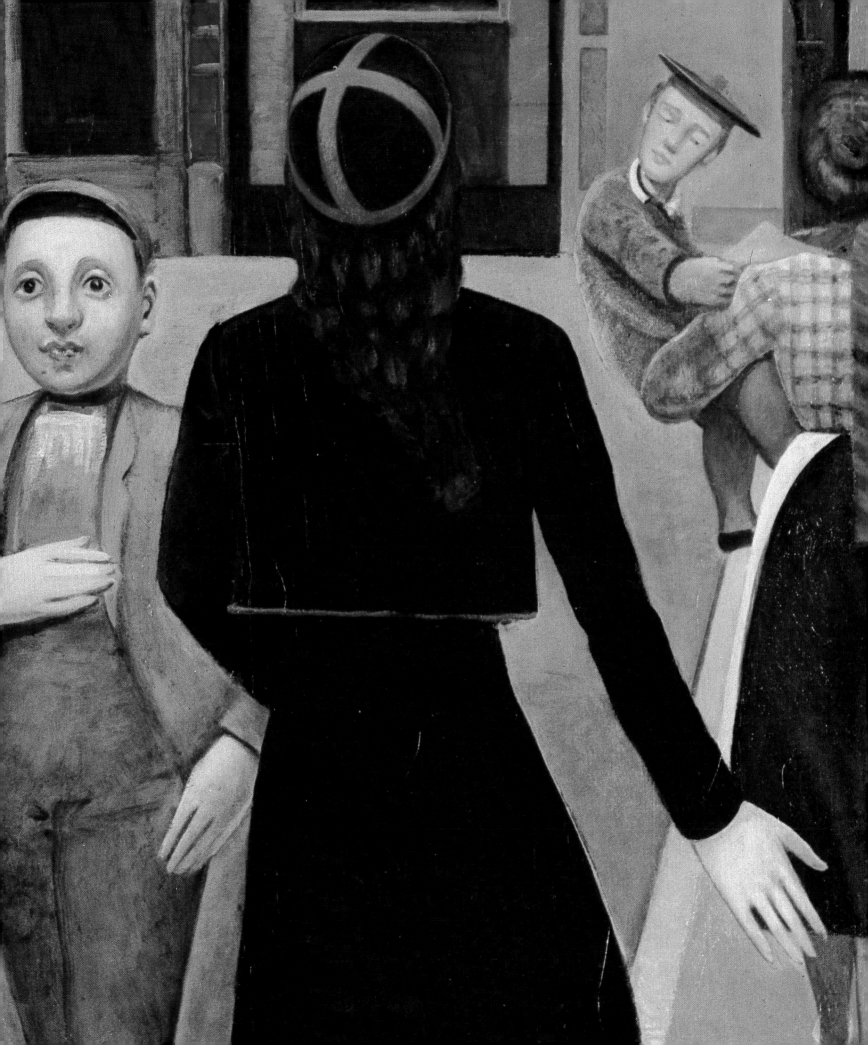

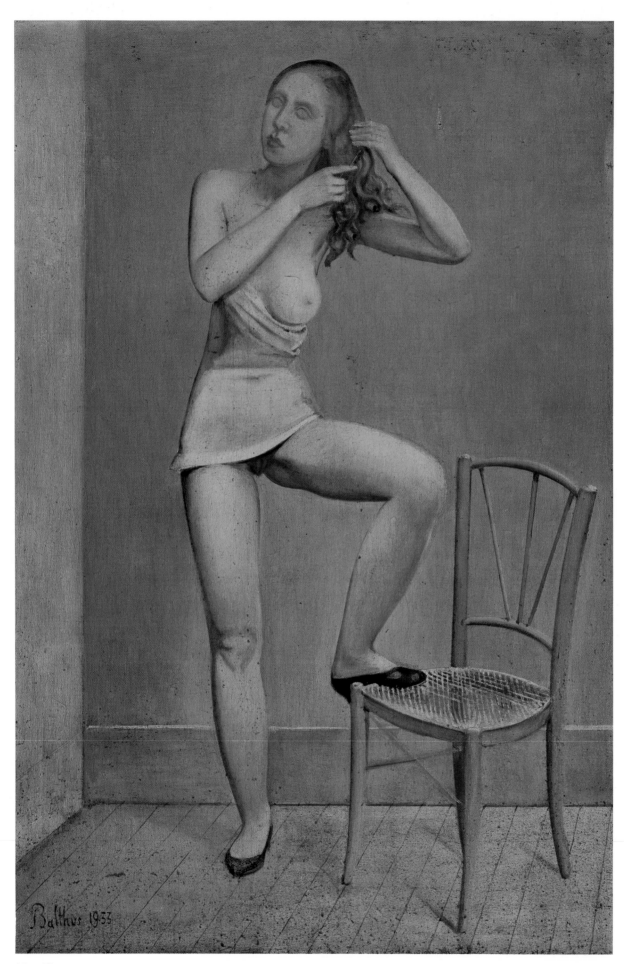

10 *Alice* 1933

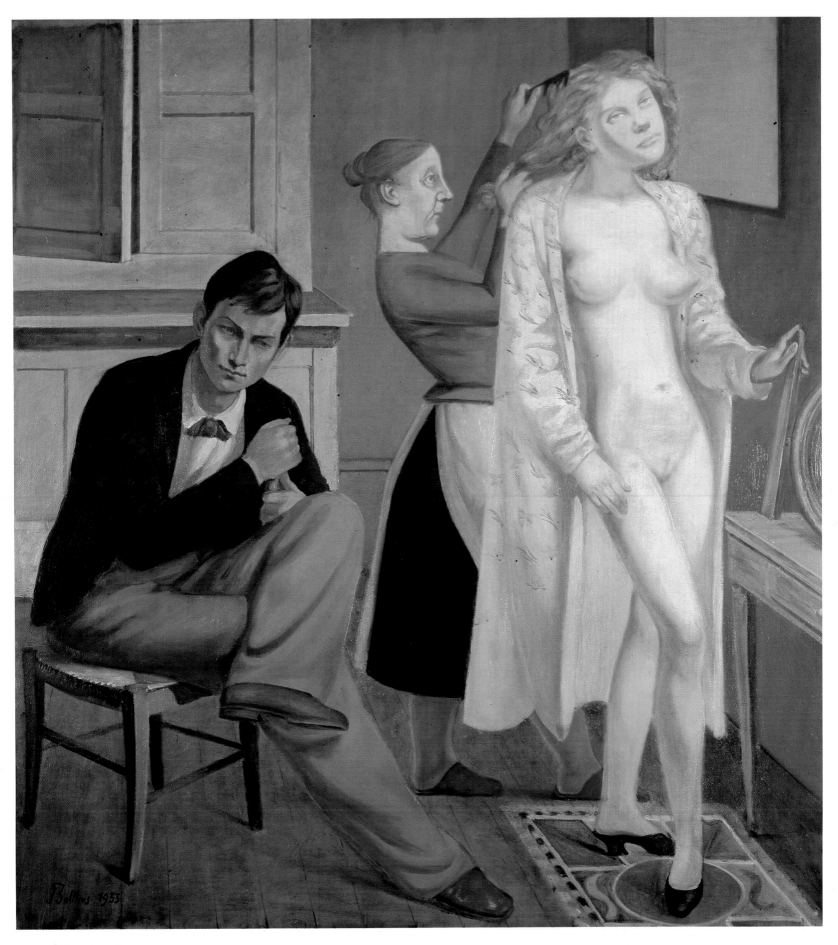

11 *La toilette de Cathie* 1933

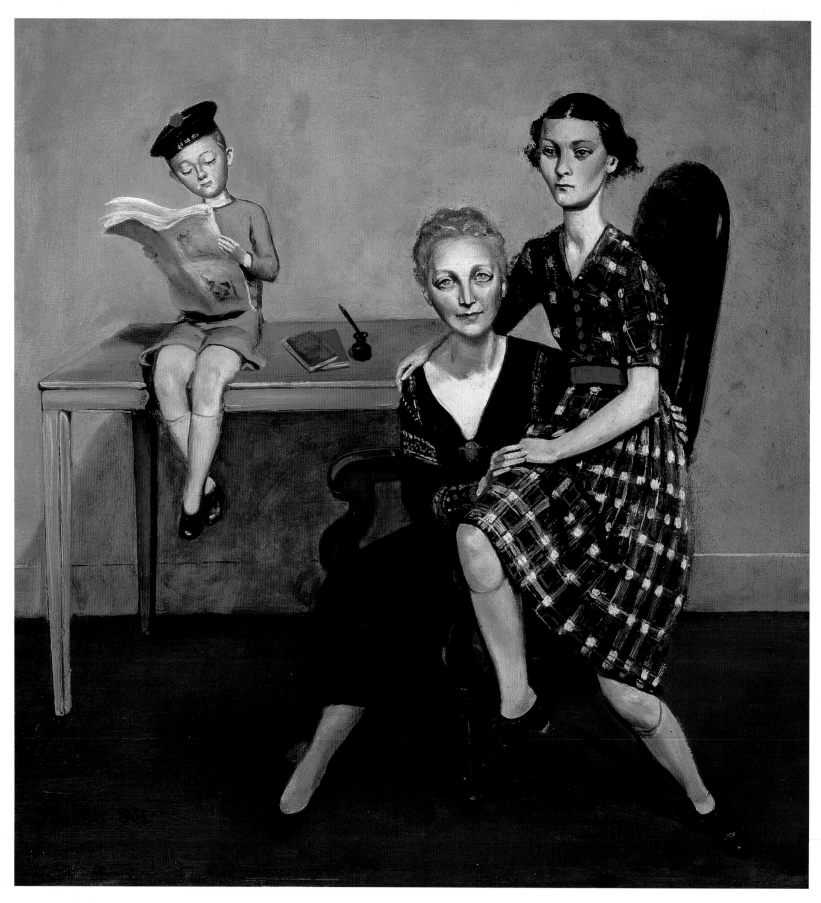

12, 13 *La famille Mouron-Cassandre* 1935

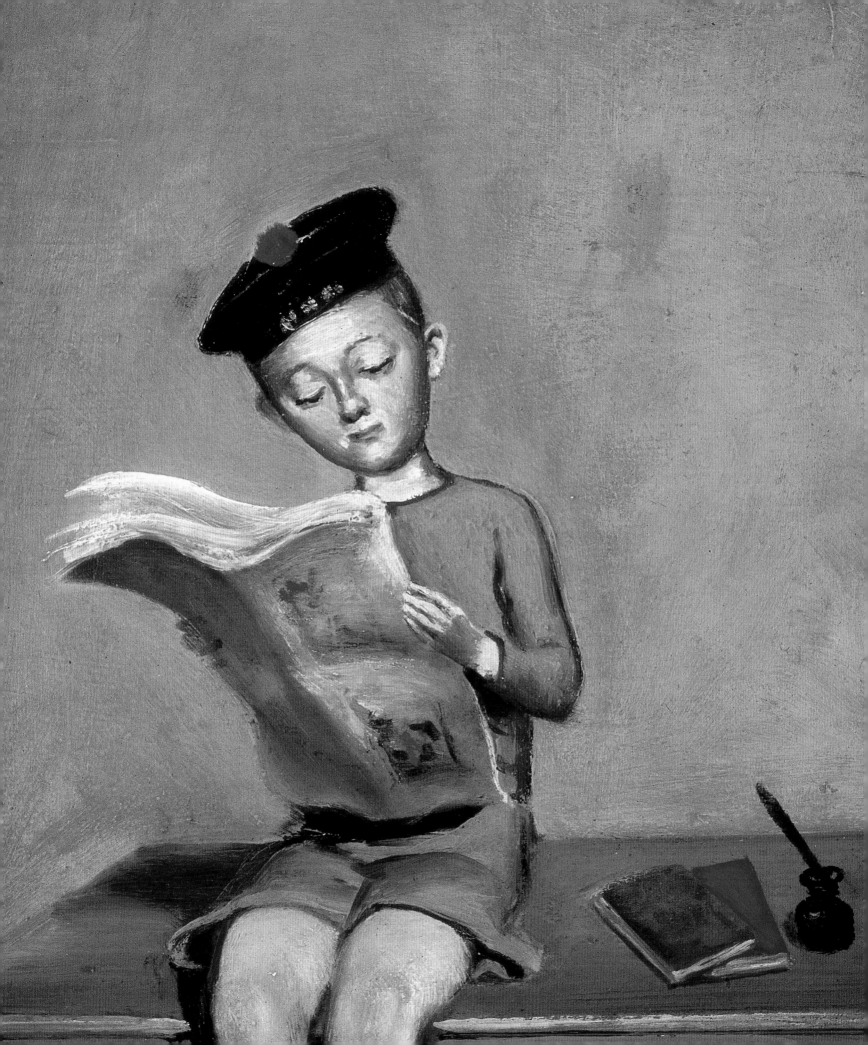

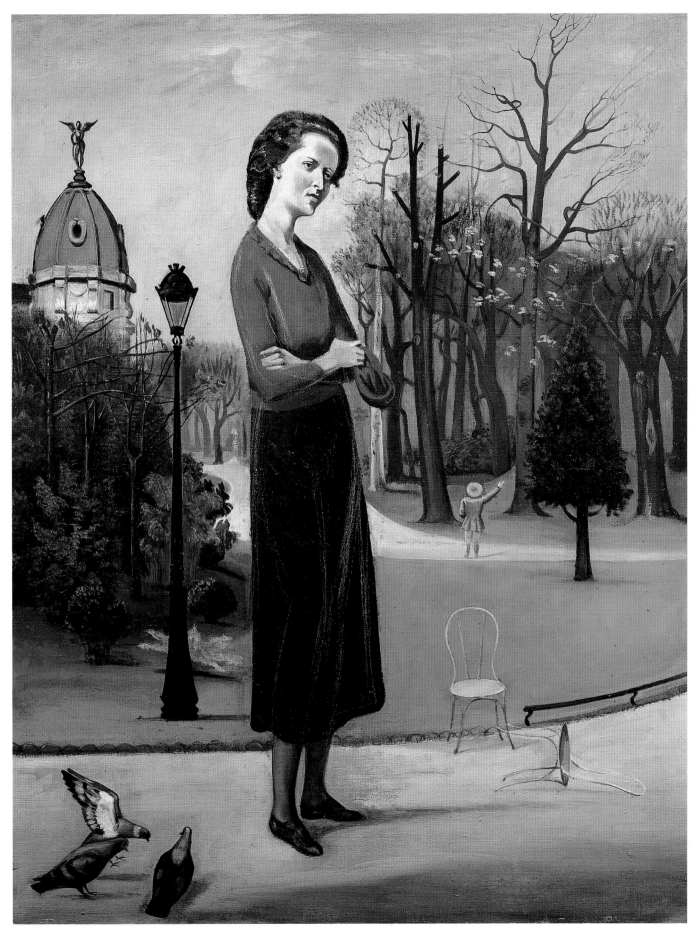

14 *Lelia Caetani* 1935

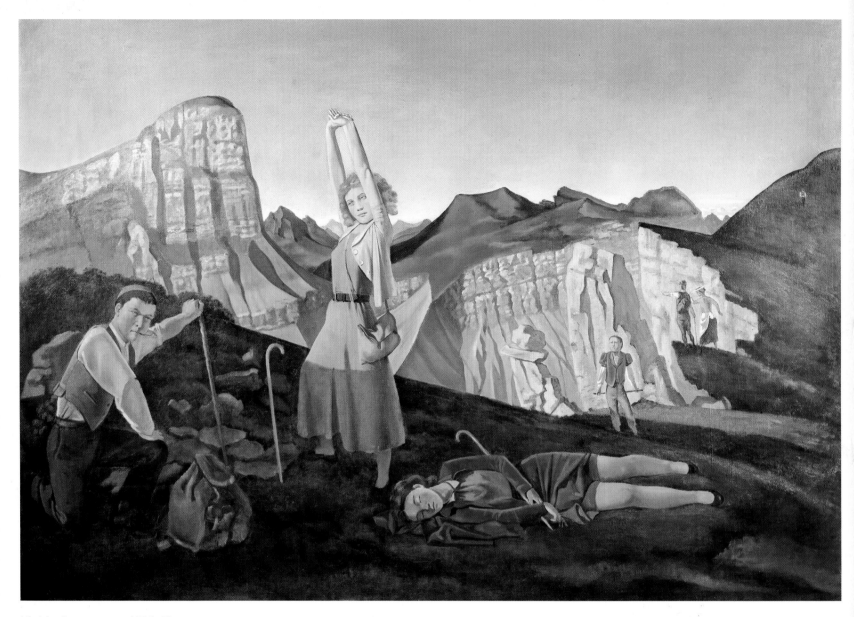

15, 16 *La montagne* 1935–37

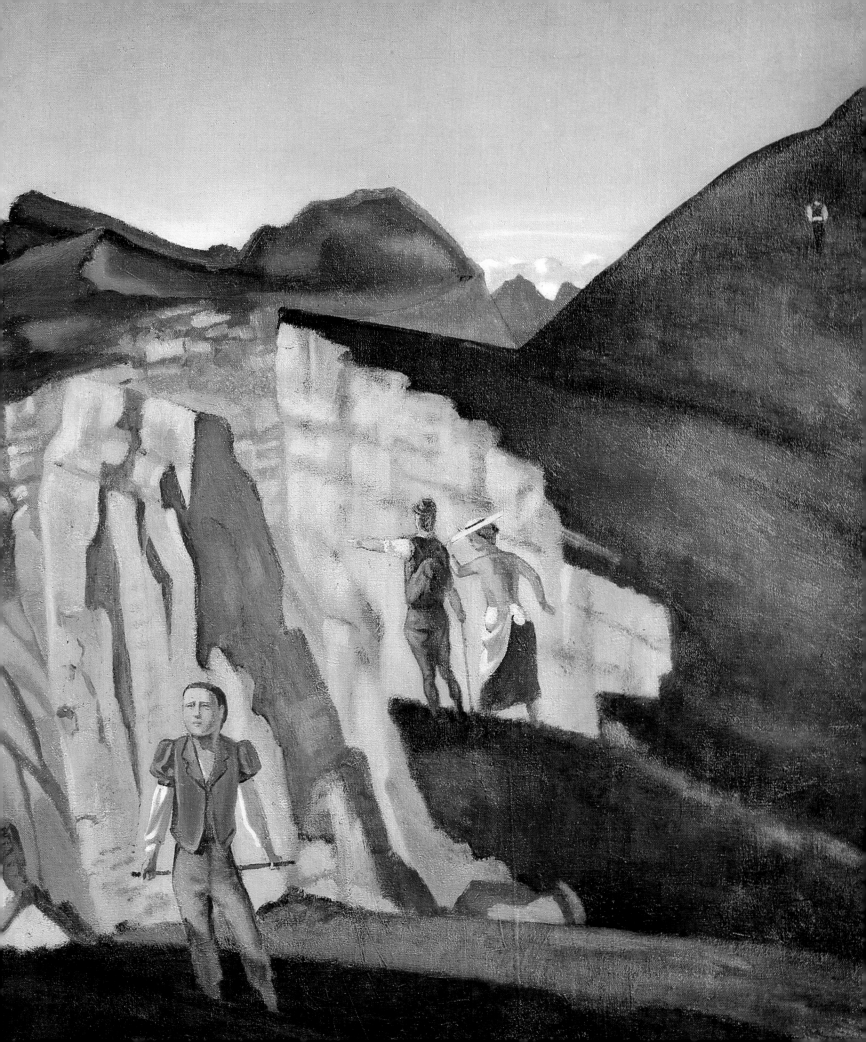

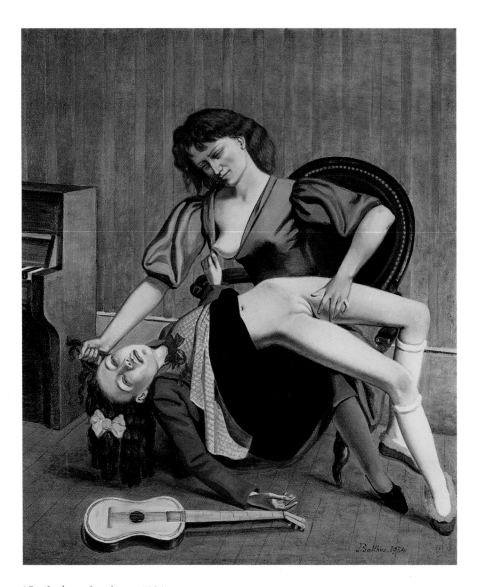

17 *La leçon de guitare* 1934

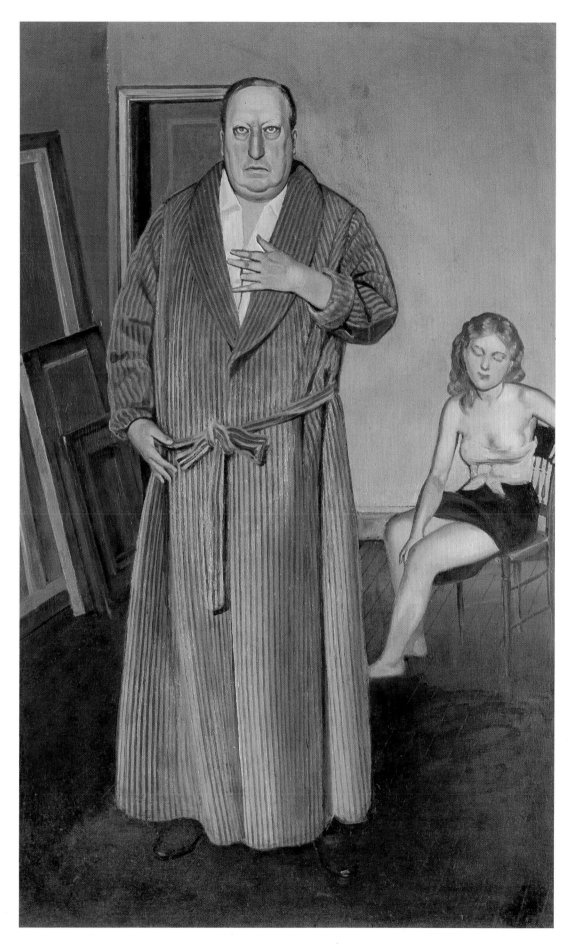

18 *André Derain* 1936

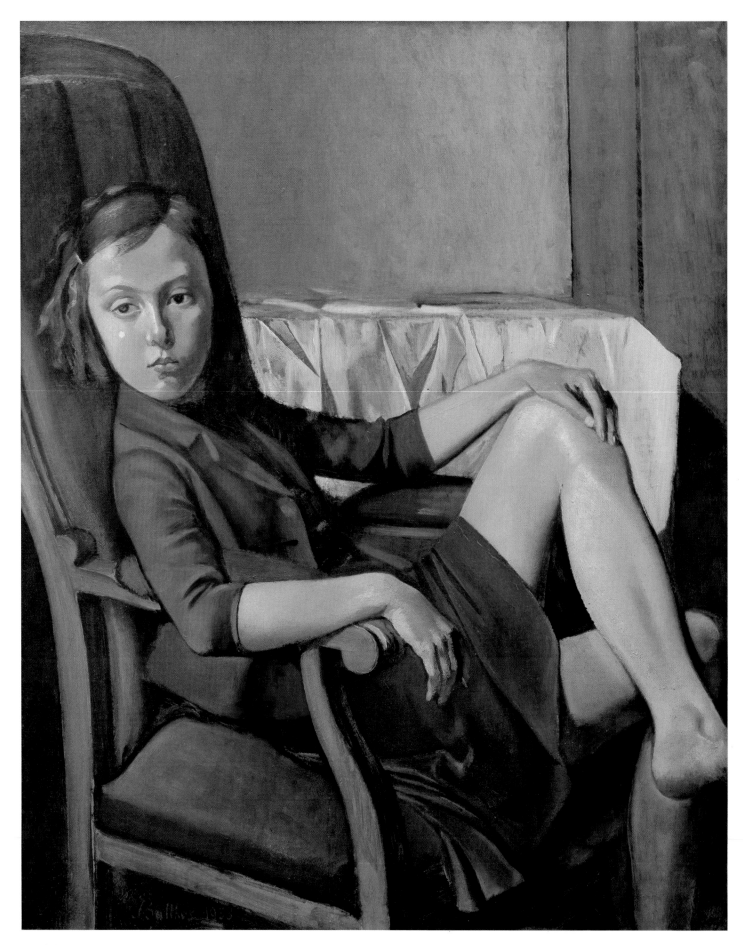

19 *Thérèse* 1938

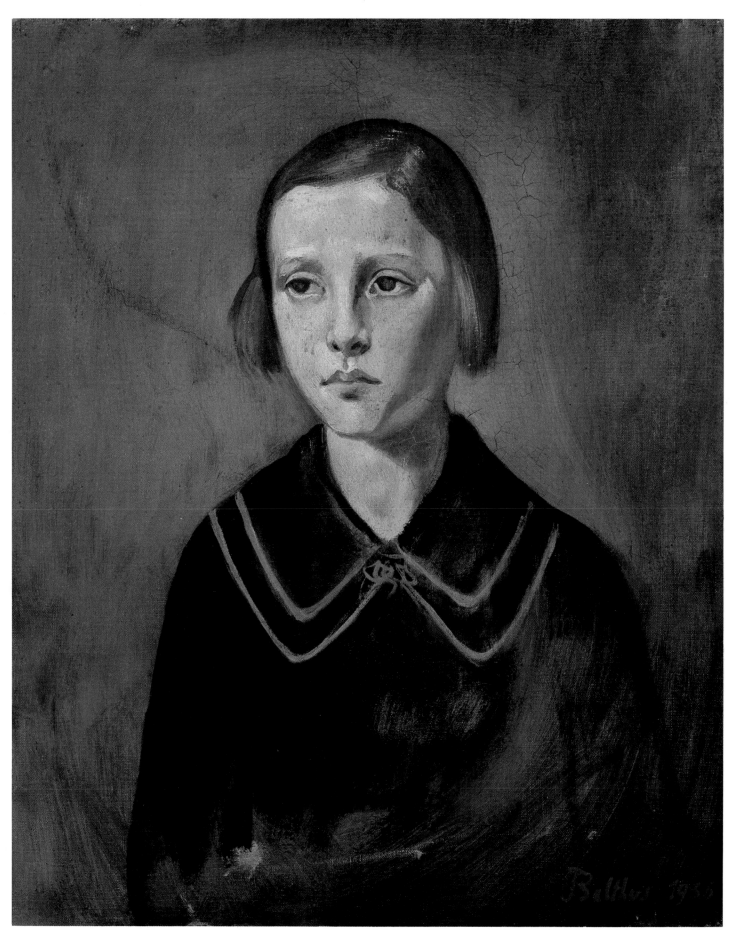

20 *Portrait de Thérèse* 1936

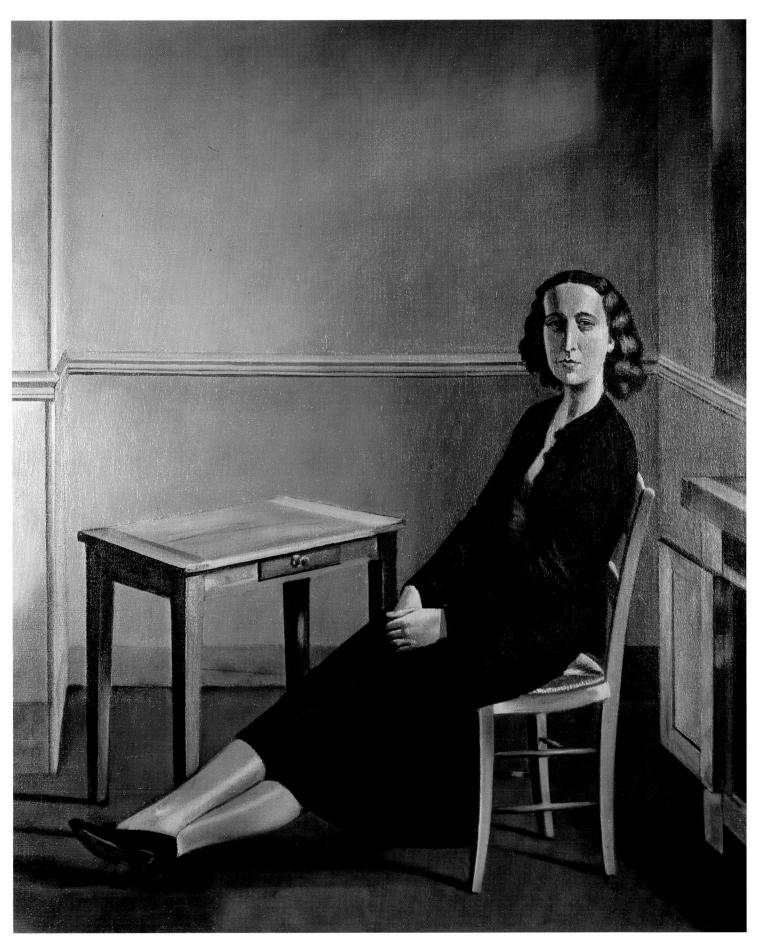

21 *Portrait de la Vicomtesse de Noailles* 1936

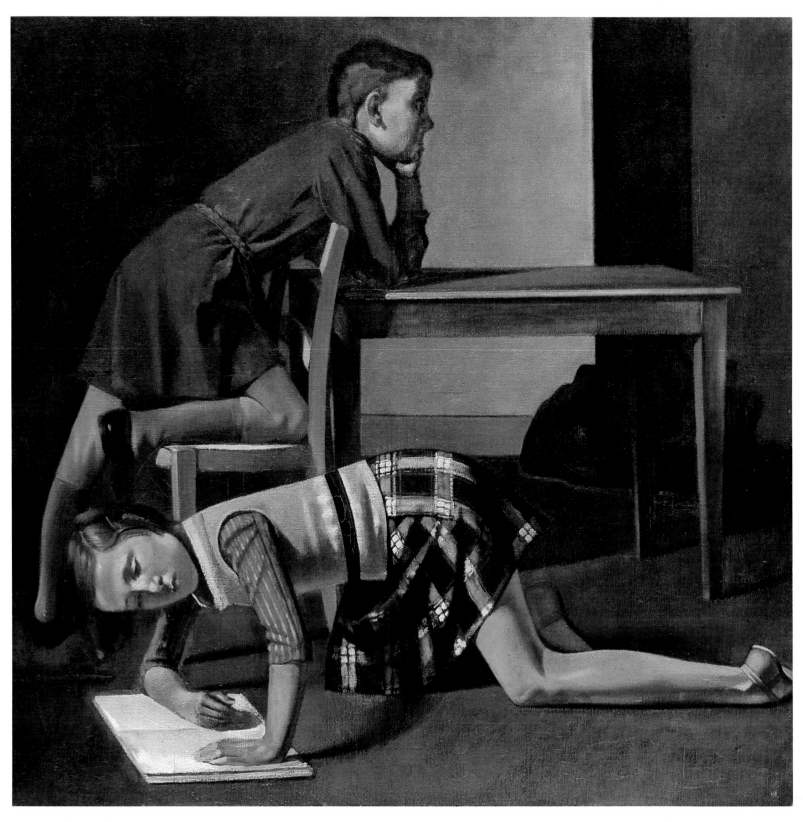

22 *Les enfants* 1937

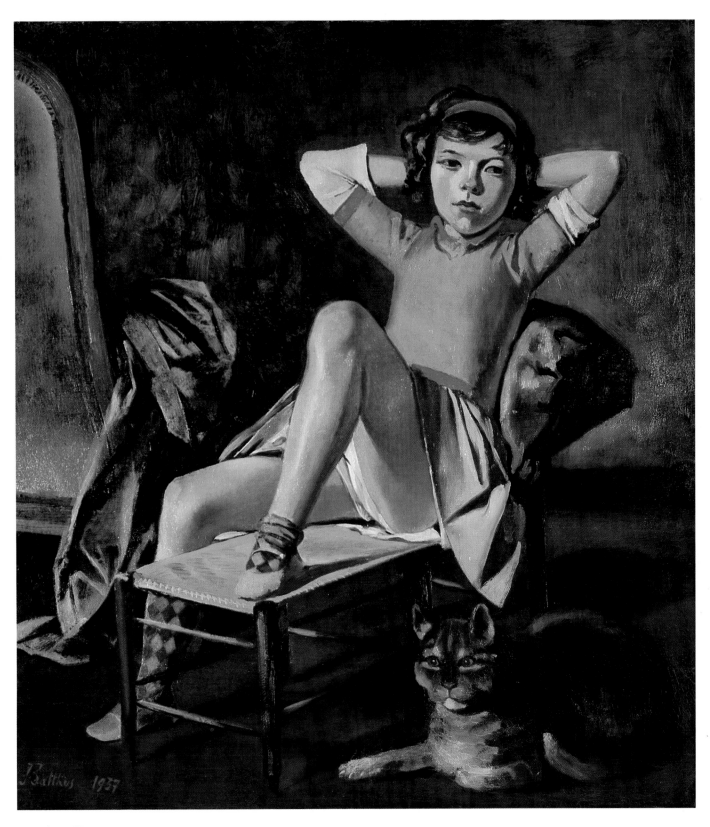

23 *Jeune fille au chat* 1937

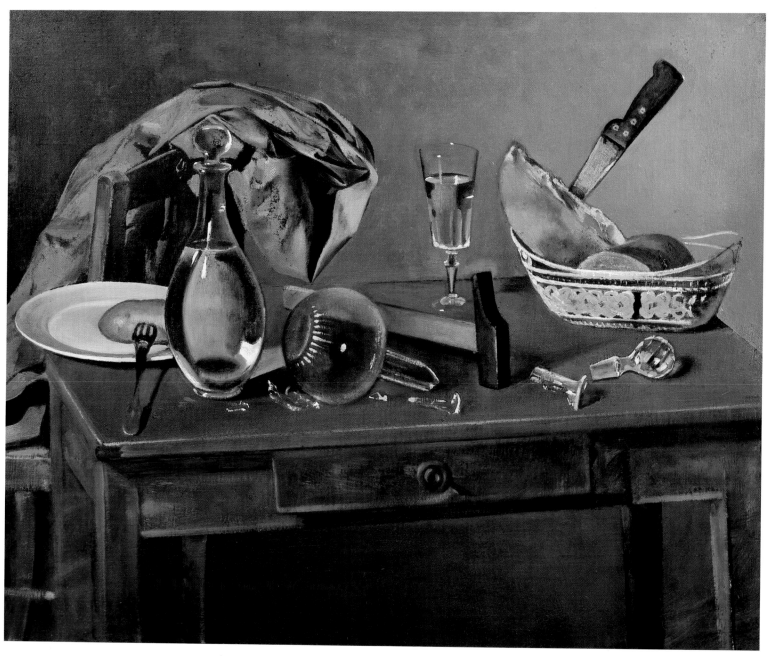

24 *Nature morte* 1937

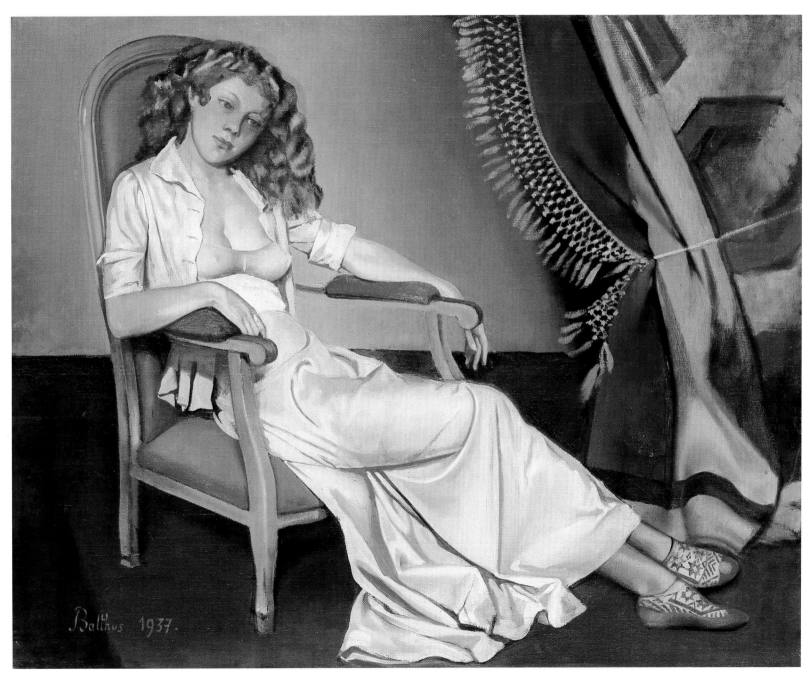

25 *La jupe blanche* 1937

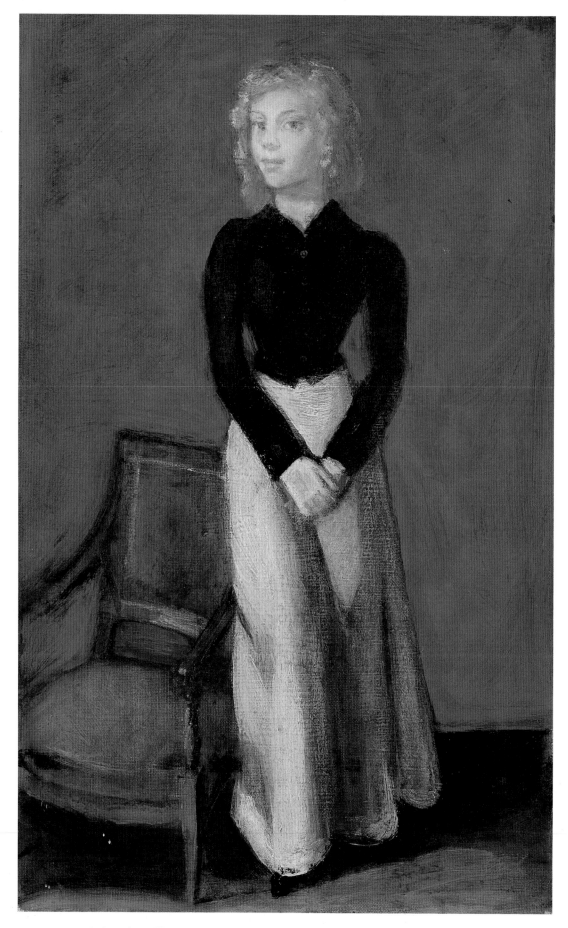

26, 27 *Portrait d'une jeune fille en costume d'amazone* 1932/1981

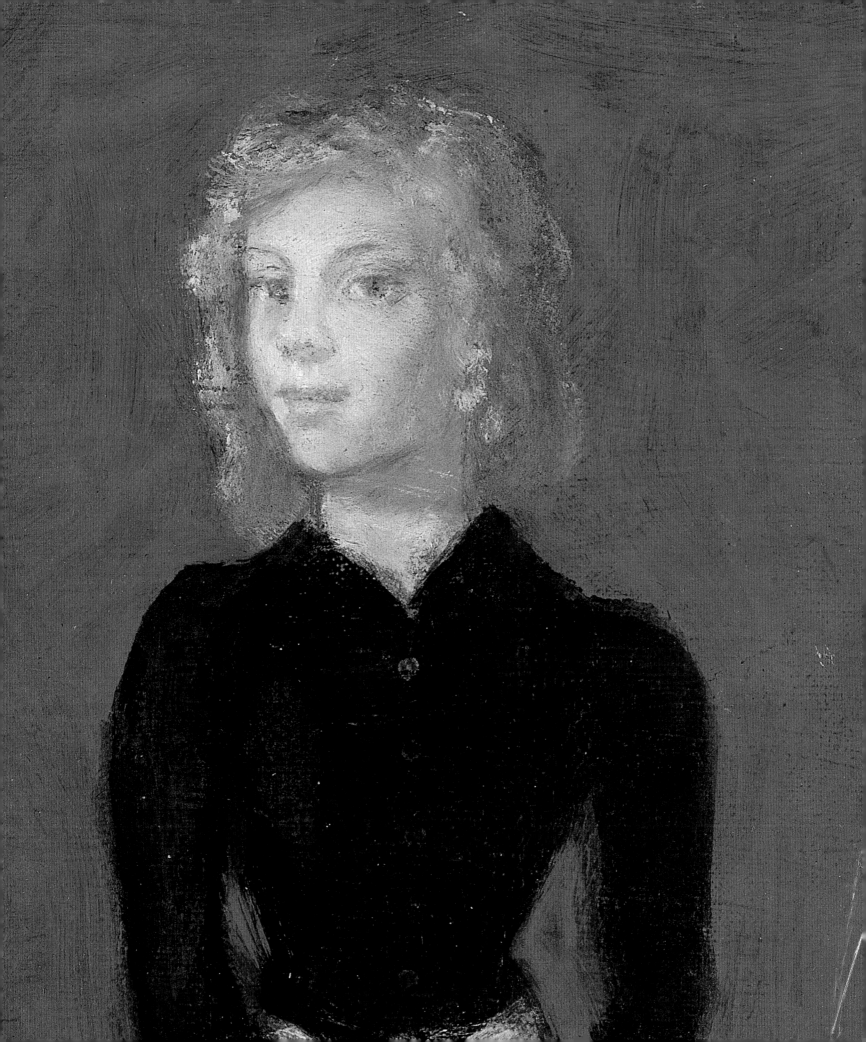

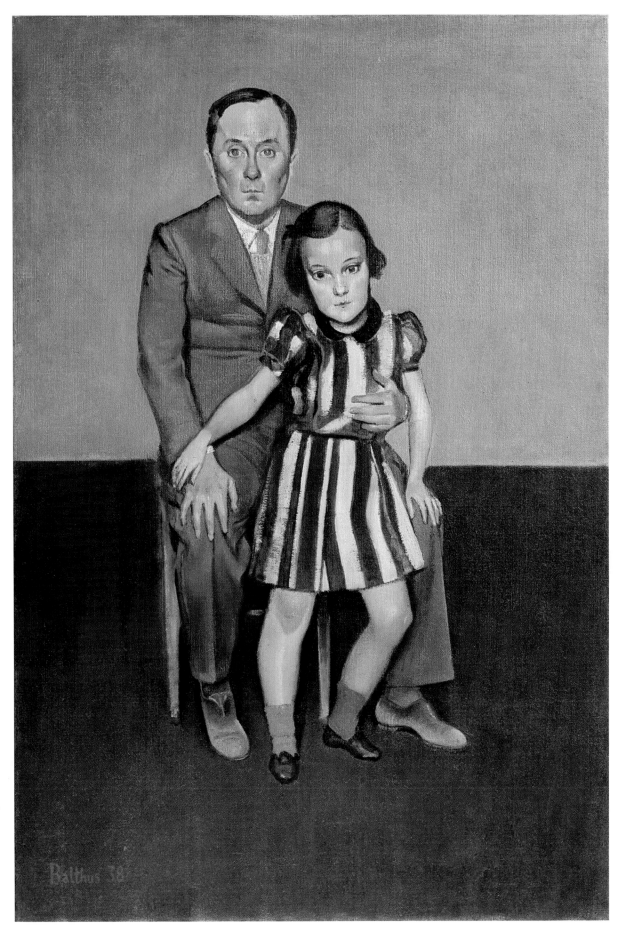

28 *Joan Miró et sa fille Dolorès* 1937–38

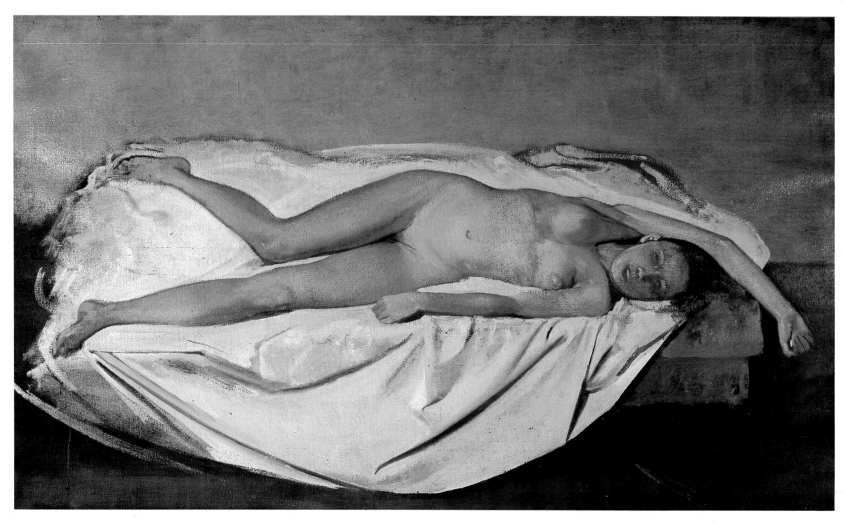

29 *La victime* 1938

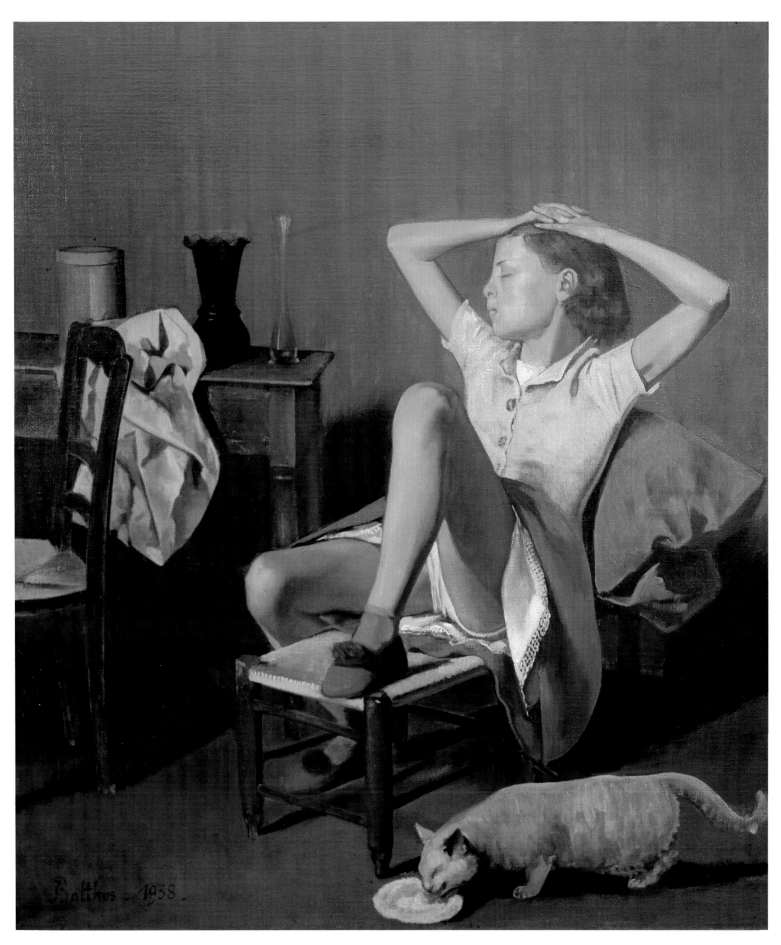

30 *Thérèse rêvant* 1938

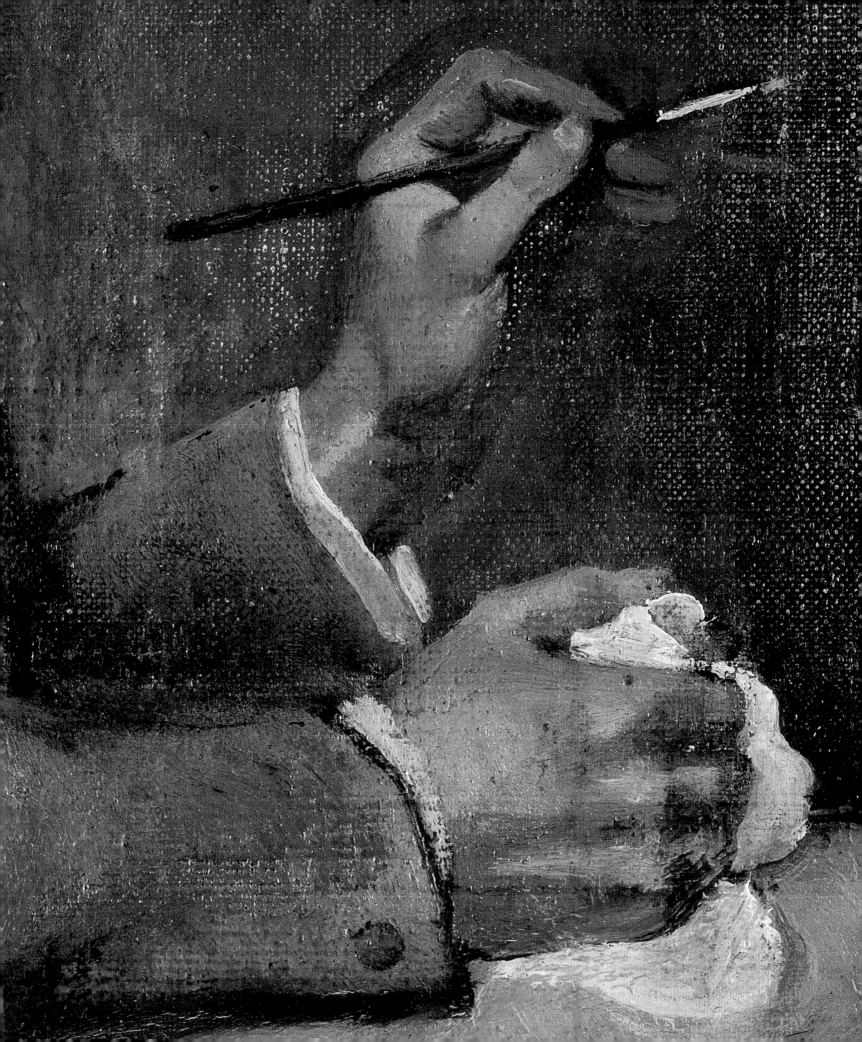

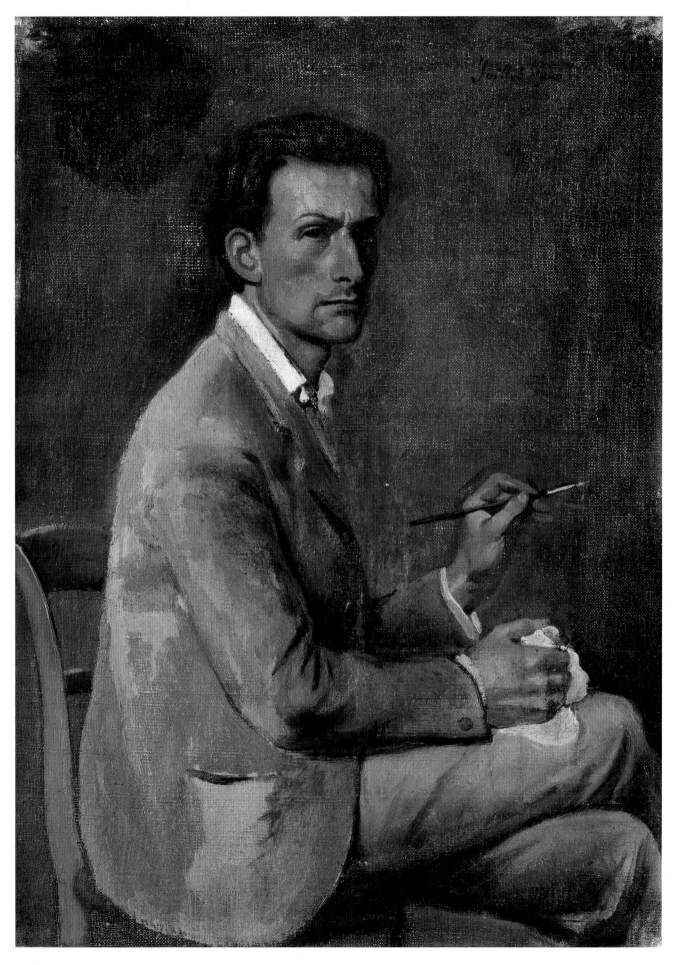

31, 32 *Autoportrait* 1940

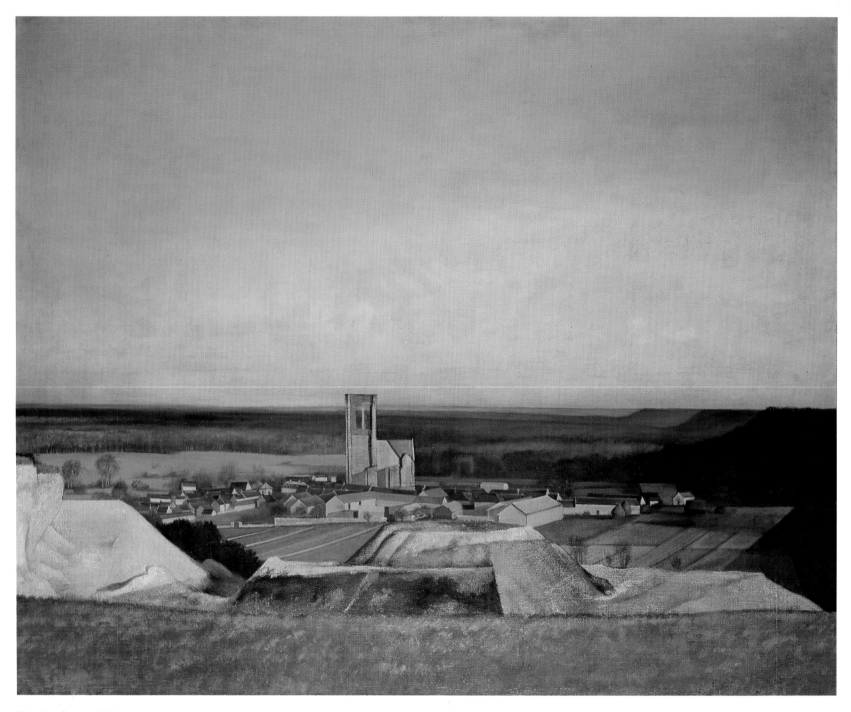

33 *Larchant* 1939

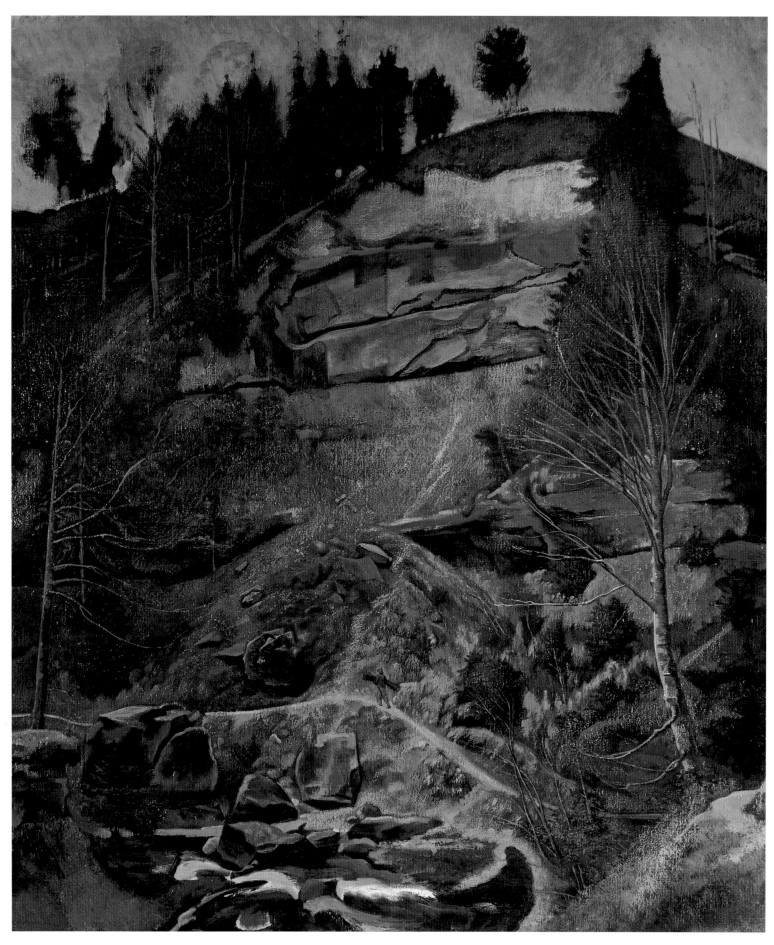

34 *Le Gottéron* 1943

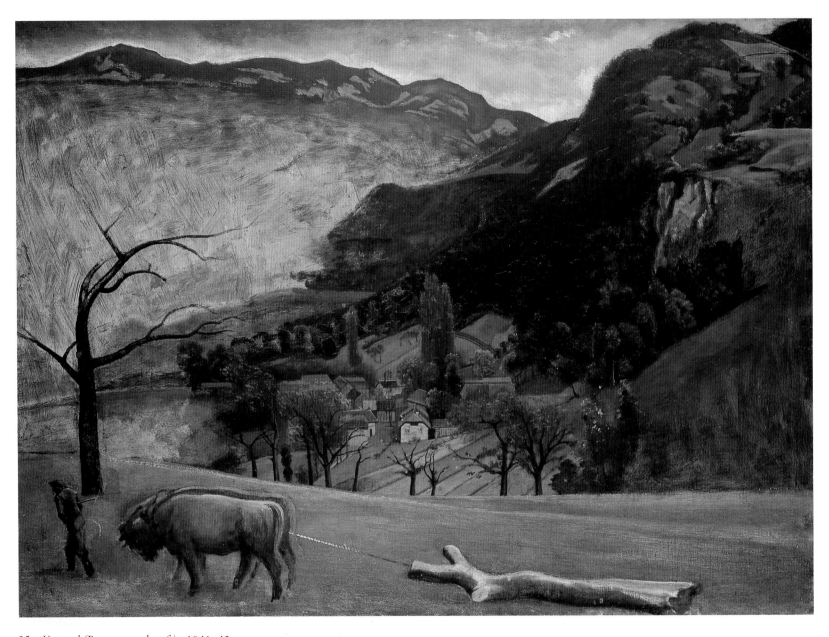

35　*Vernatel (Paysage aux boeufs)*　1941–42

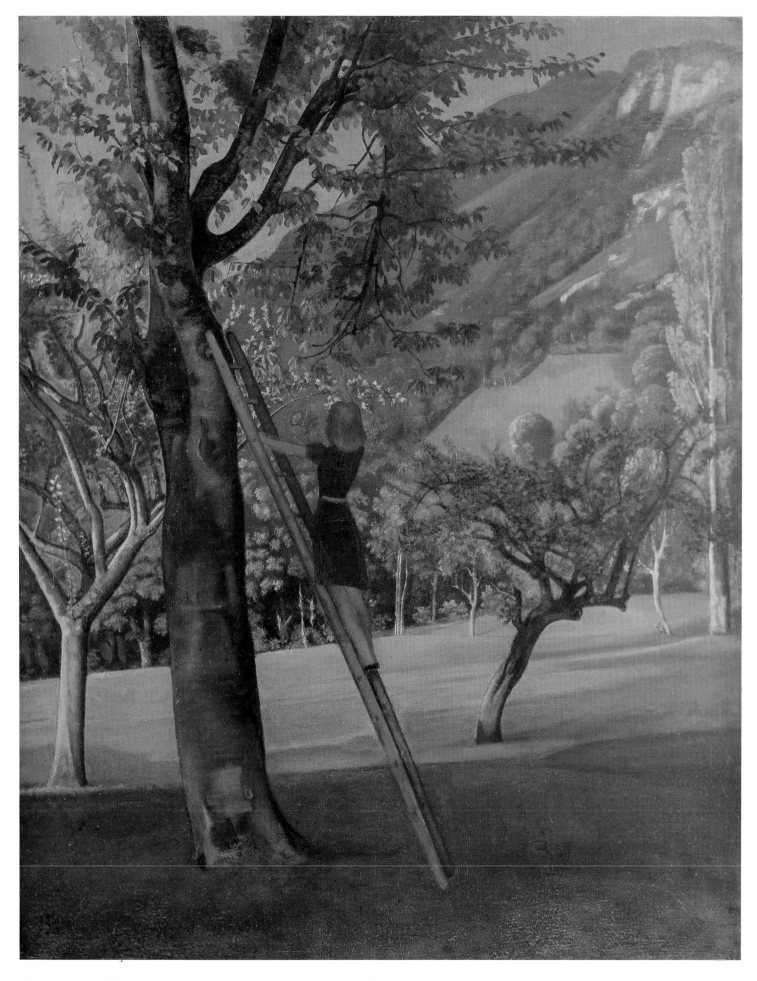

36 *Le cerisier* 1940

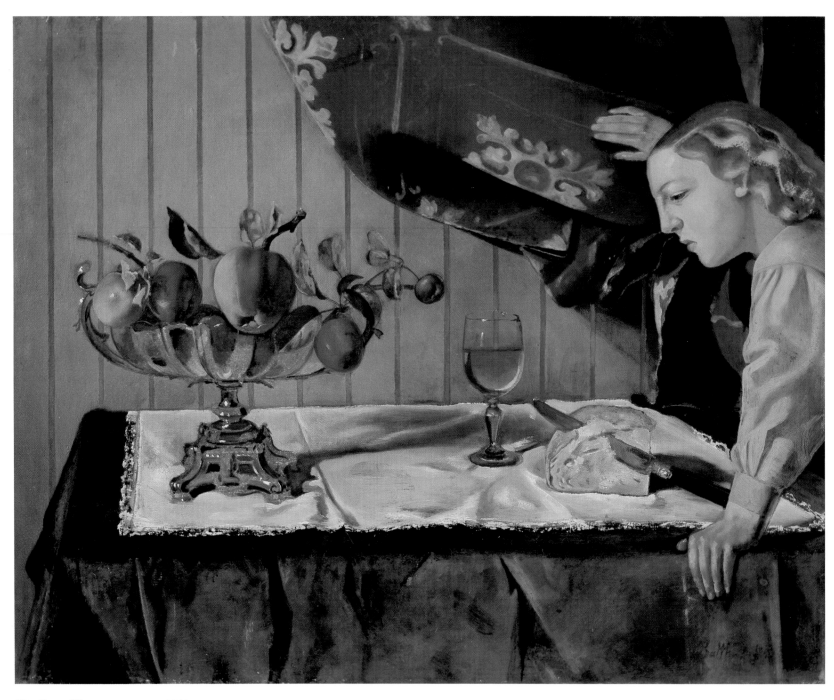

37 *Jeune fille et nature morte* 1942

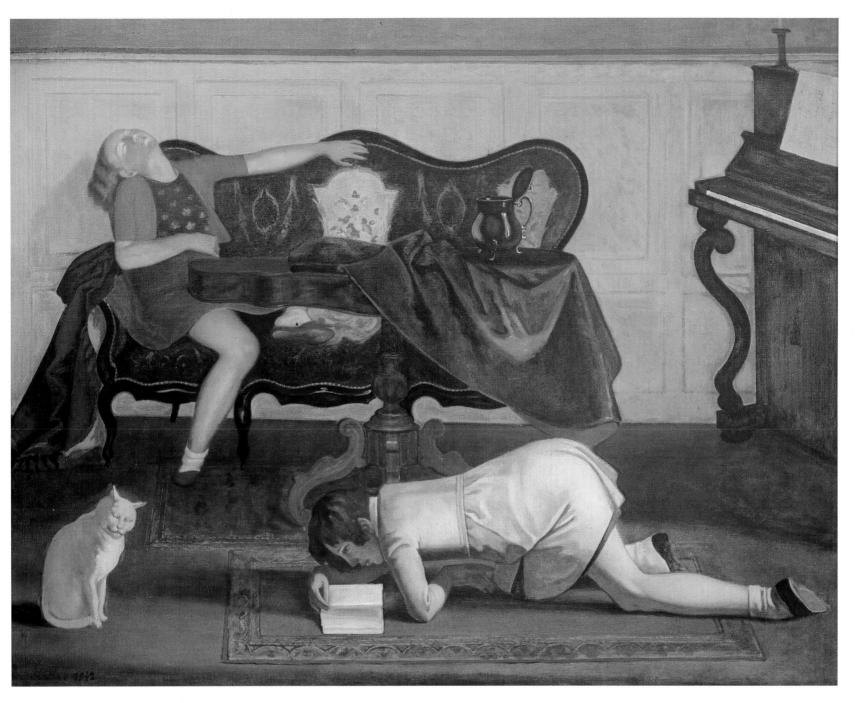

38 *Le salon* 1942

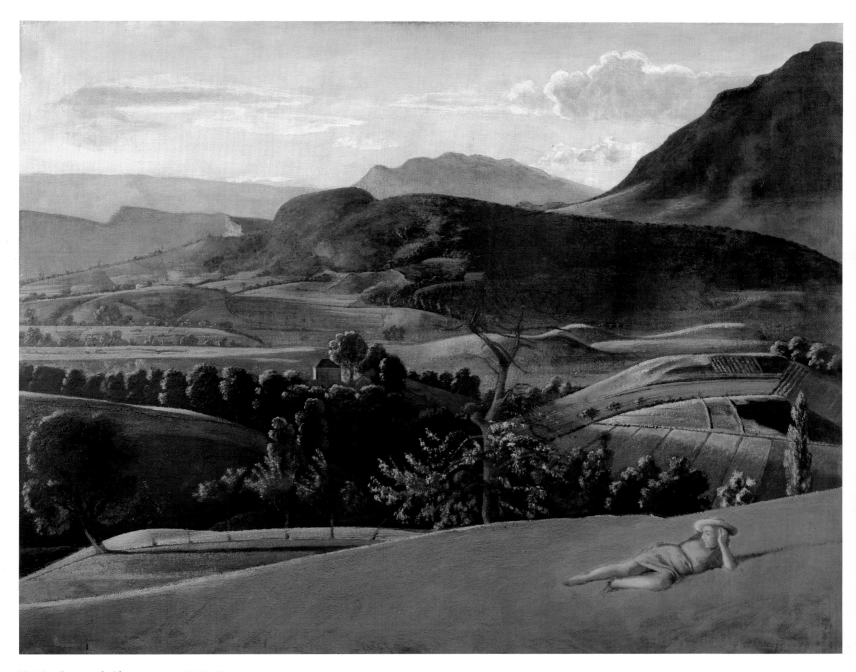

39, 40 *Paysage de Champrovent* 1942–45

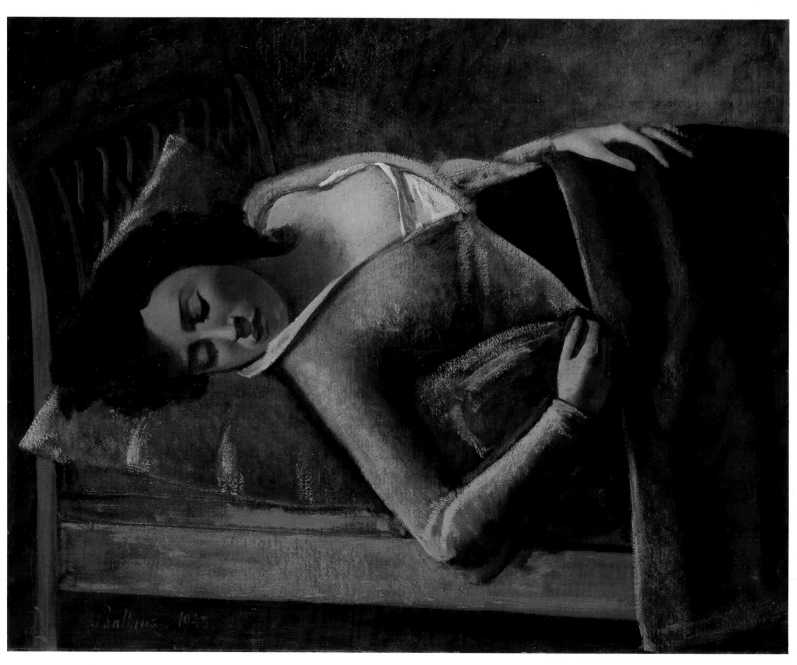

41 *La jeune fille endormie* 1943

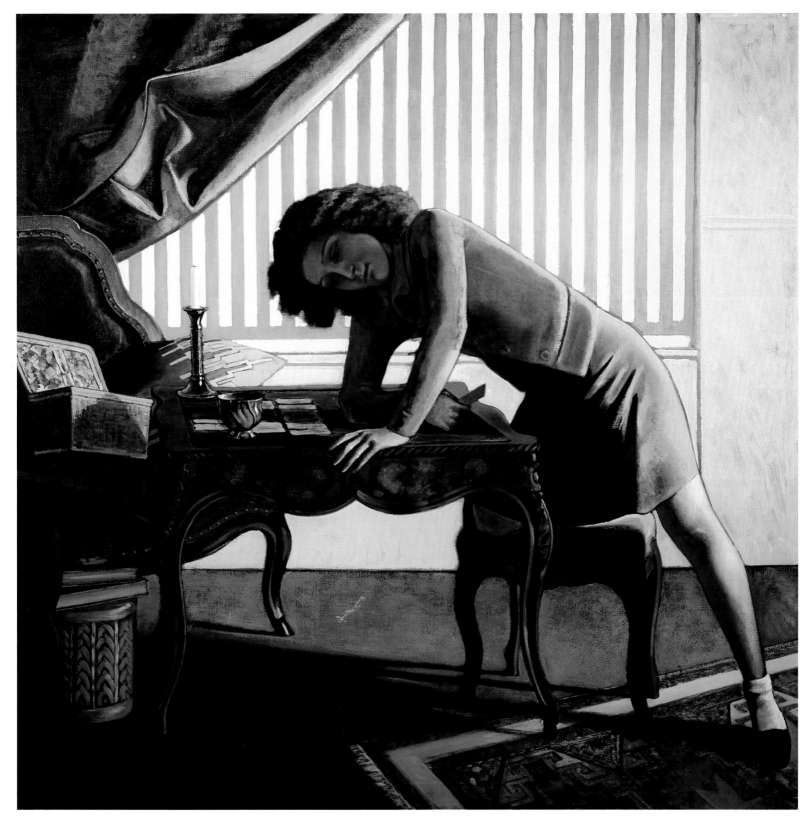

42 *La patience* 1943

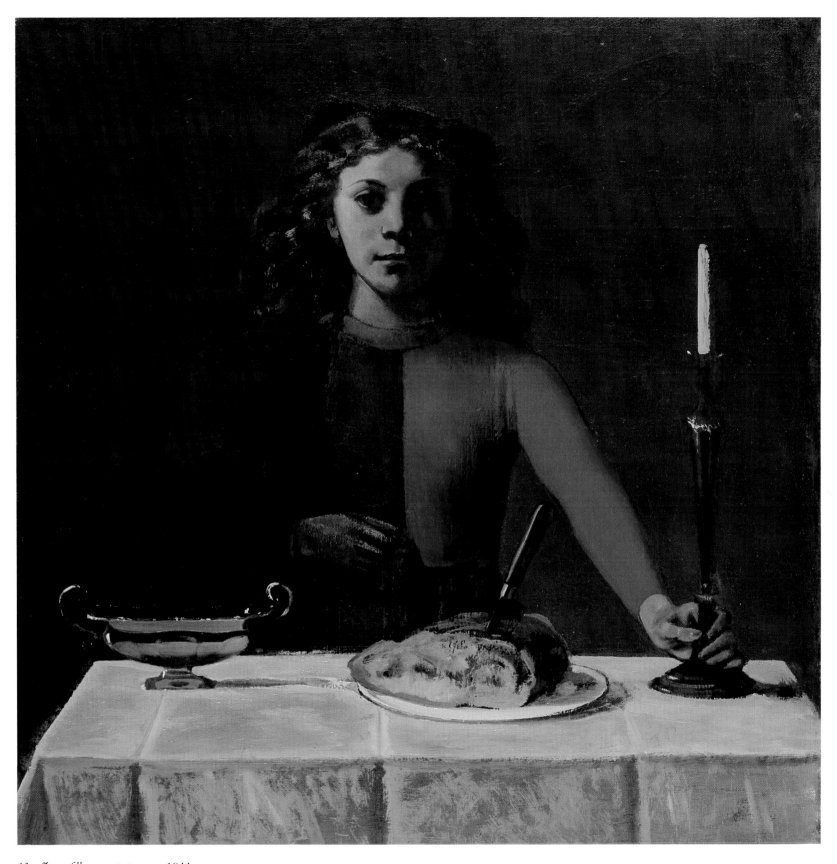

43 *Jeune fille en vert et rouge* 1944

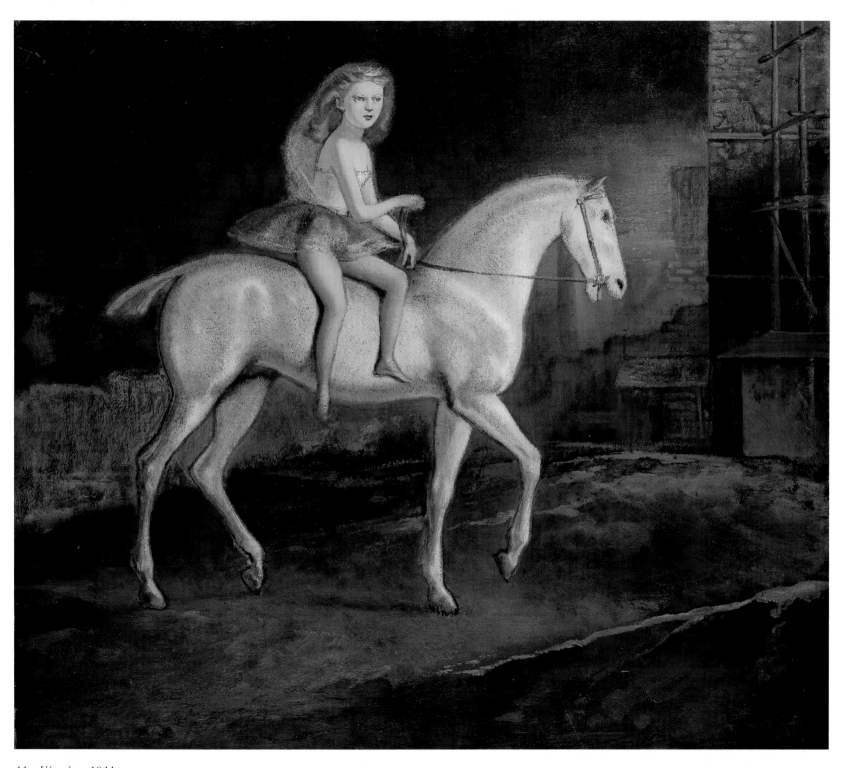

44 *L'écuyère* 1944

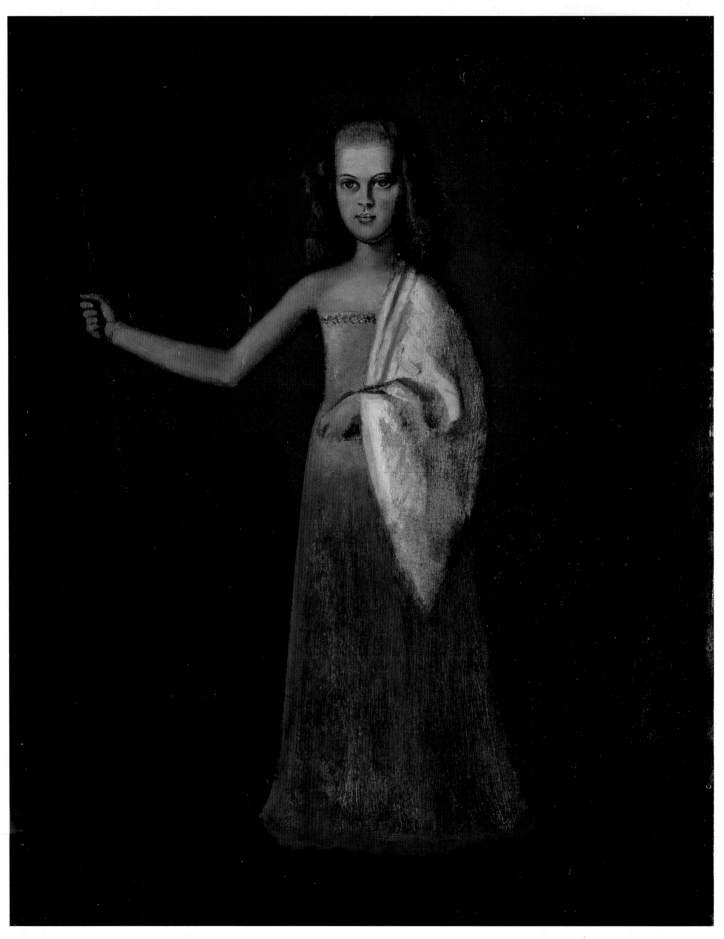

45, 46 *La princesse Maria Volkonski à l'âge de douze ans* 1945

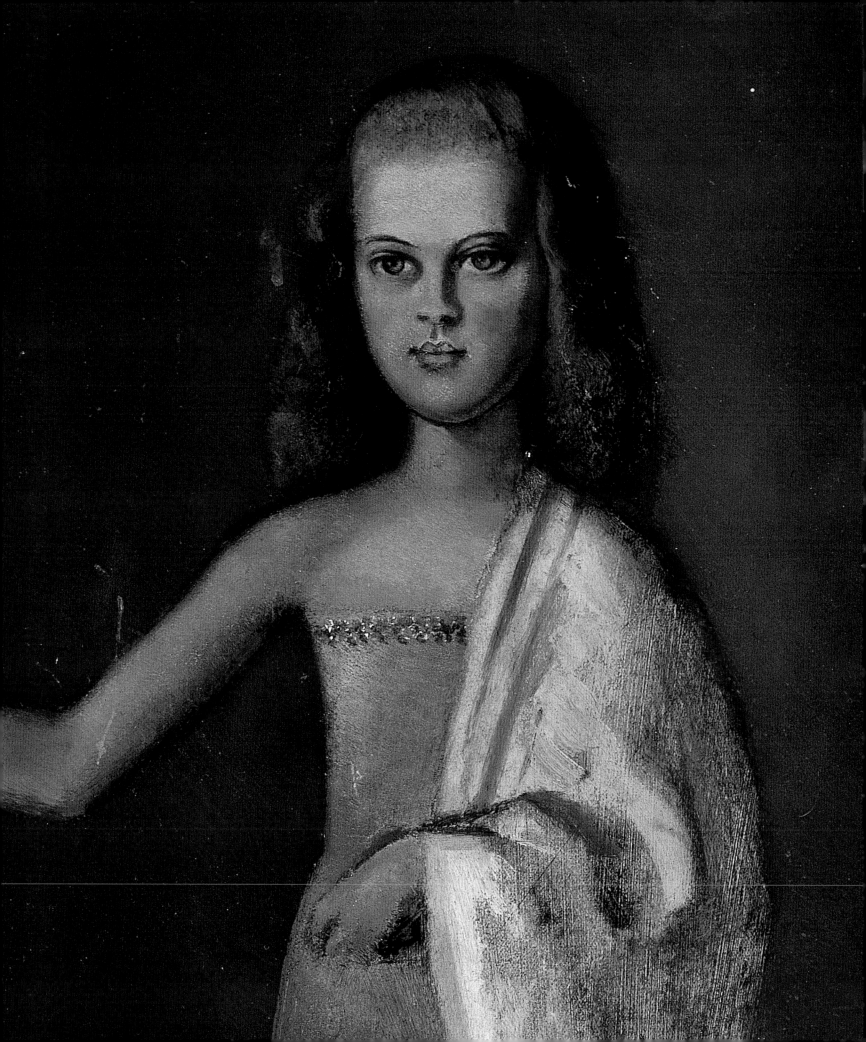

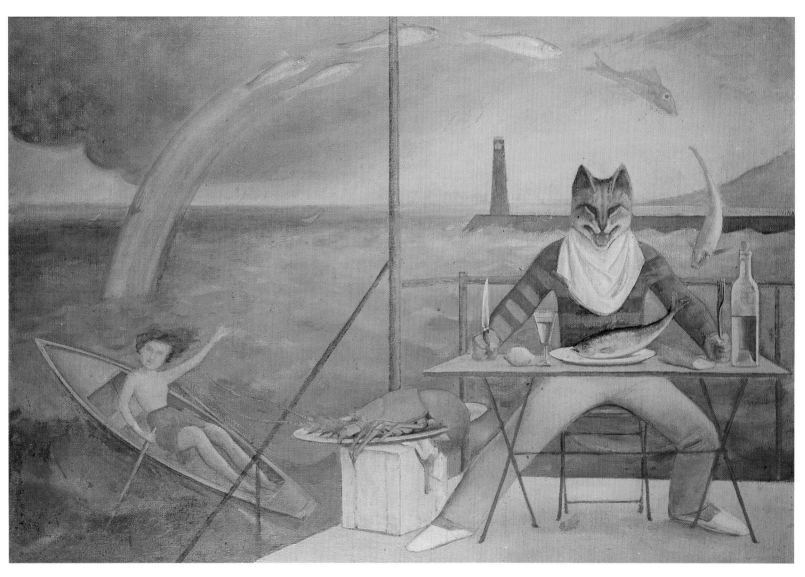

47 *Le chat de La Méditerranée* 1949

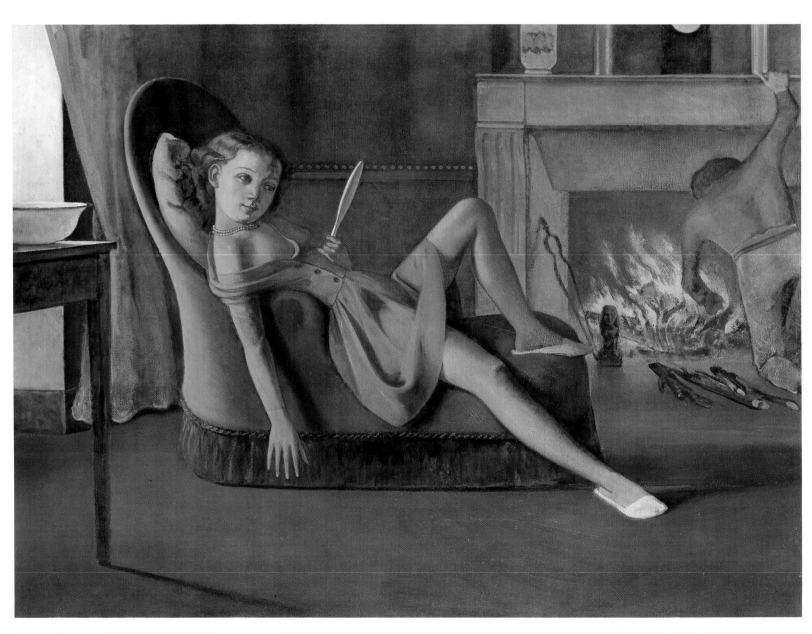

48 *Les beaux jours* 1944–45

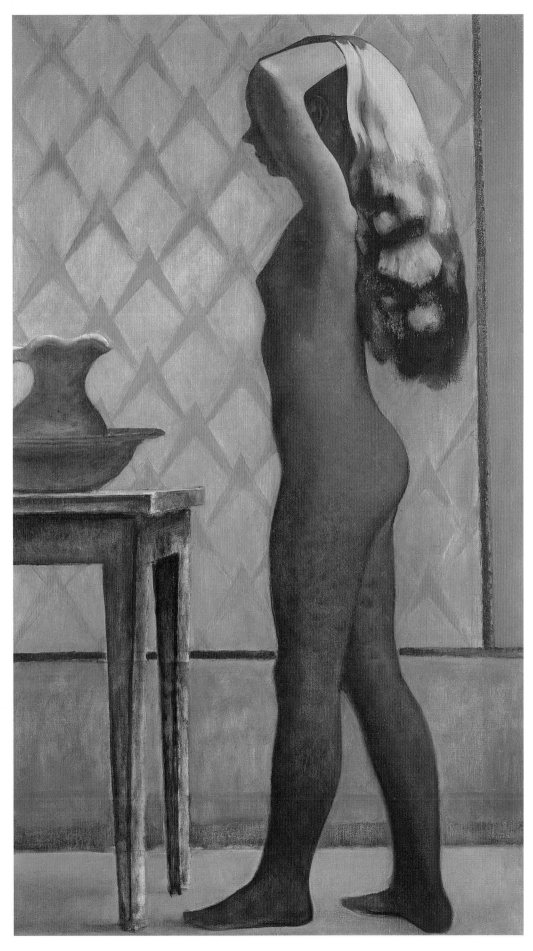

49 *Jeune fille à sa toilette* 1949–51

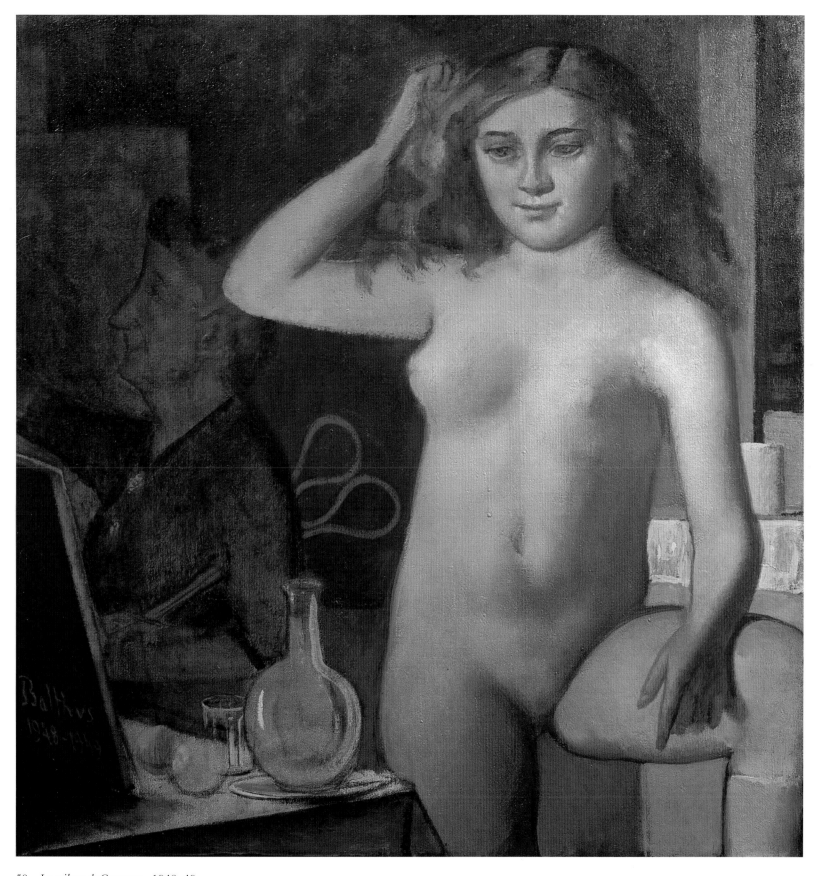

50 *La toilette de Georgette* 1948–49

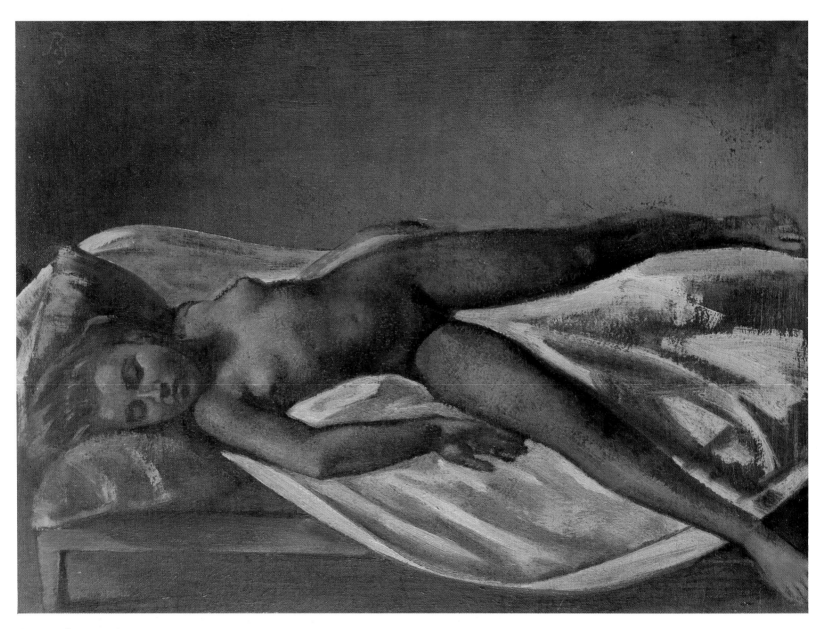

51 *Nu allongé* 1950

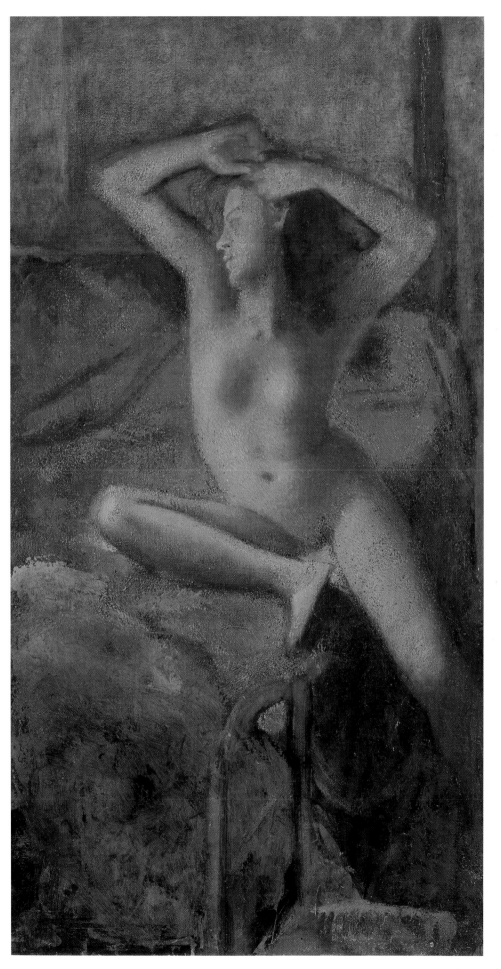

52 *Nu aux bras levés* 1951

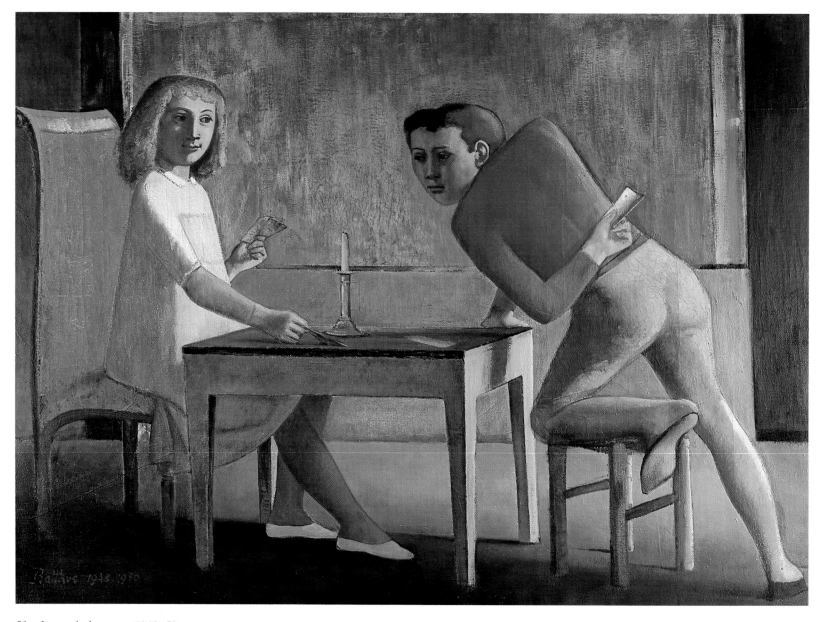

53 *La partie de cartes* 1948–50

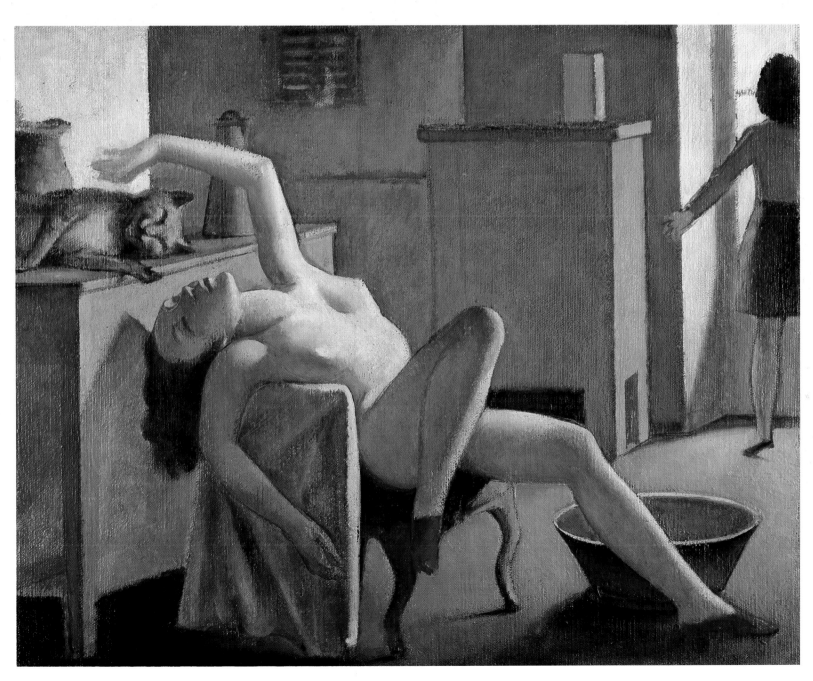

54 *Nu jouant avec un chat* 1949

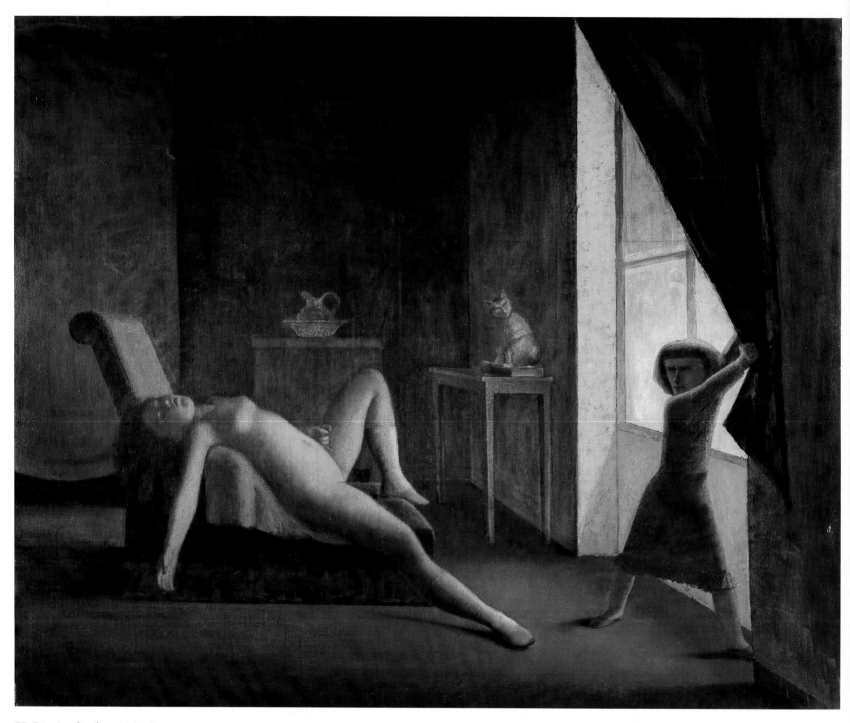

55, 56 *La chambre* 1952–54

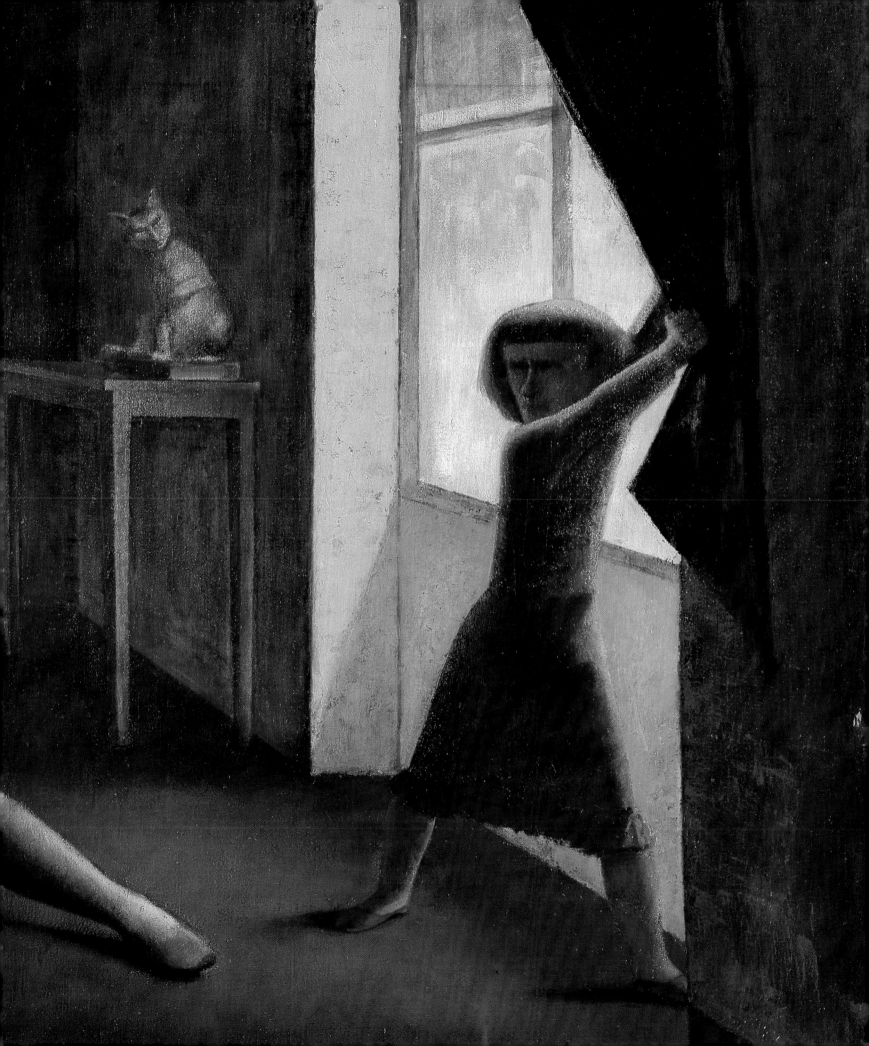

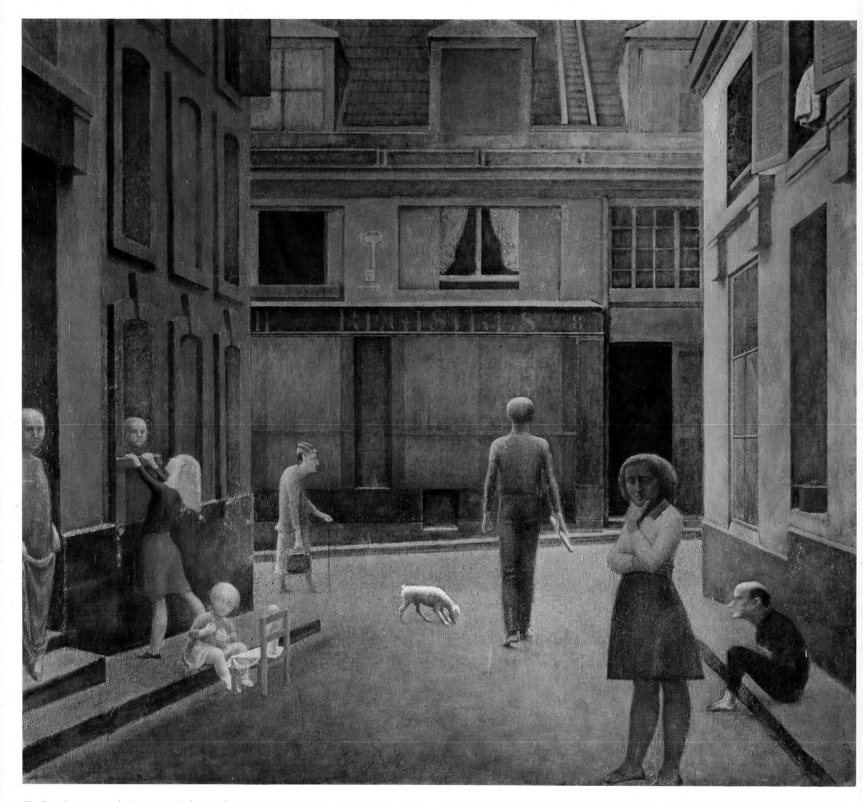

57, 58 *Le passage du Commerce Saint-André* 1952–54

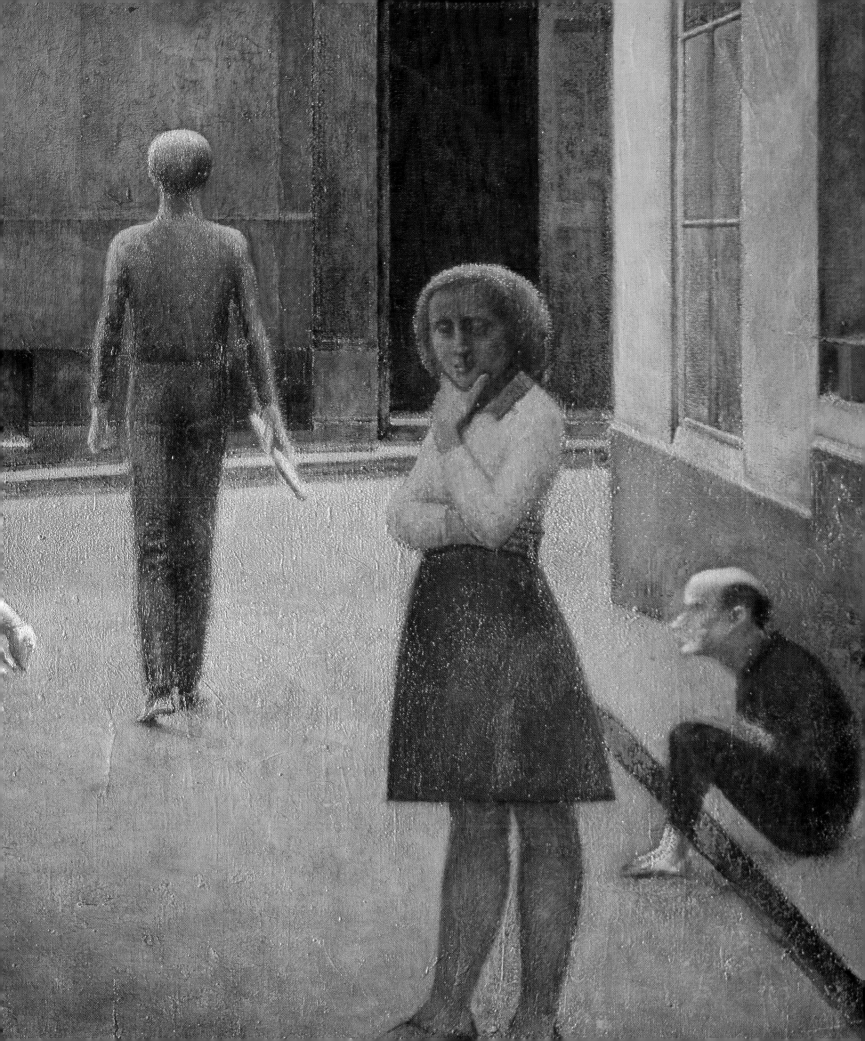

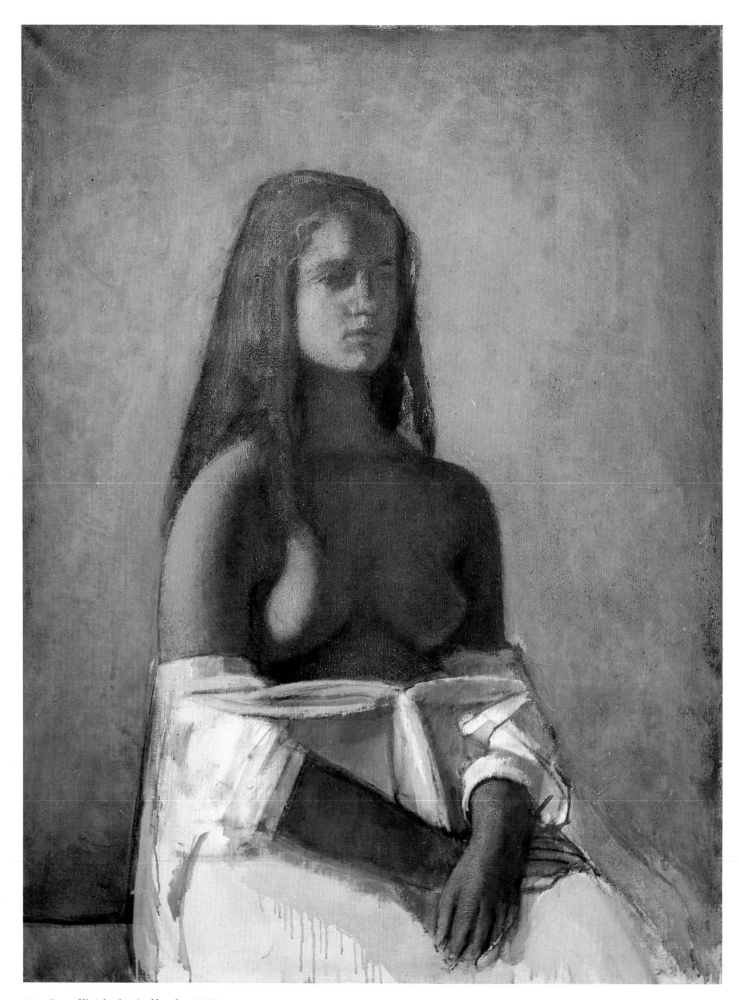

59 *Jeune fille à la chemise blanche* 1955

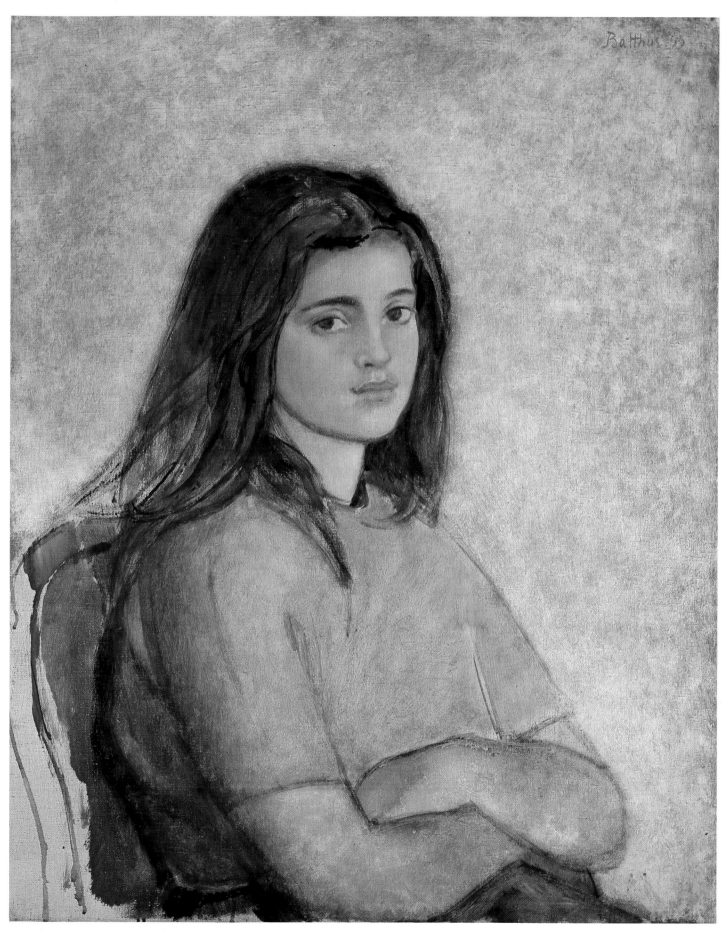

60 *Frédérique* 1955

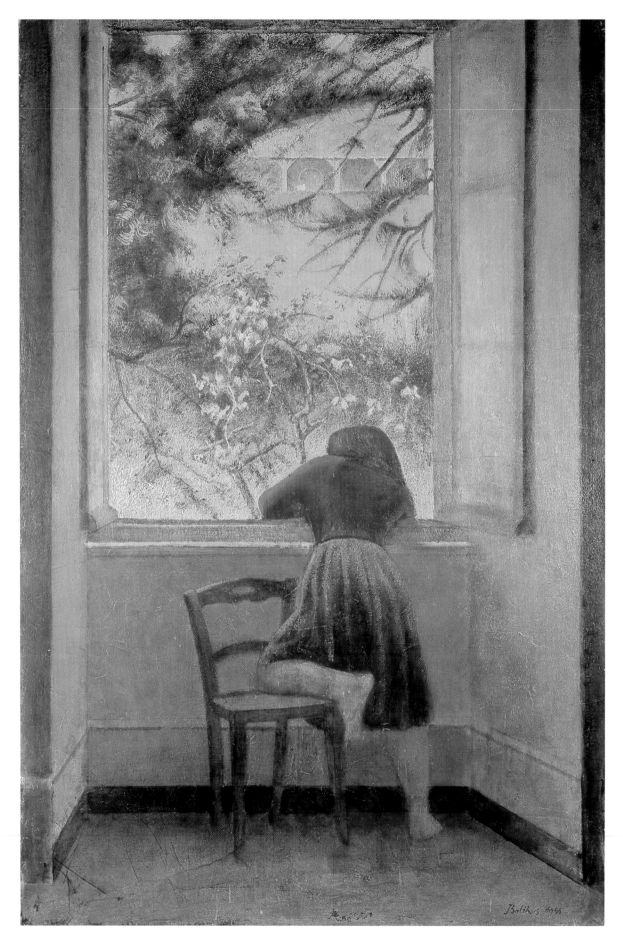

61 *Jeune fille à la fenêtre* 1955

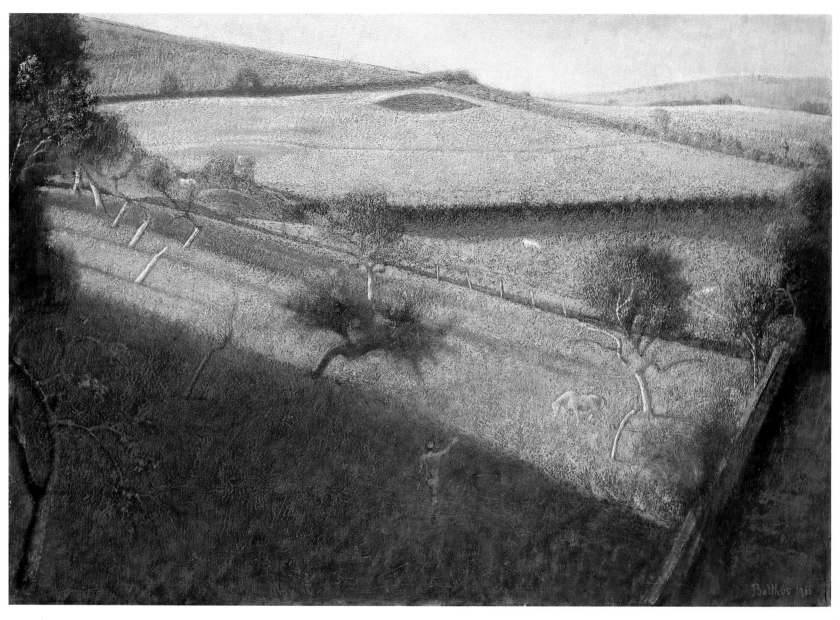

62 *Grand paysage aux arbres (Le champ triangulaire)* 1955

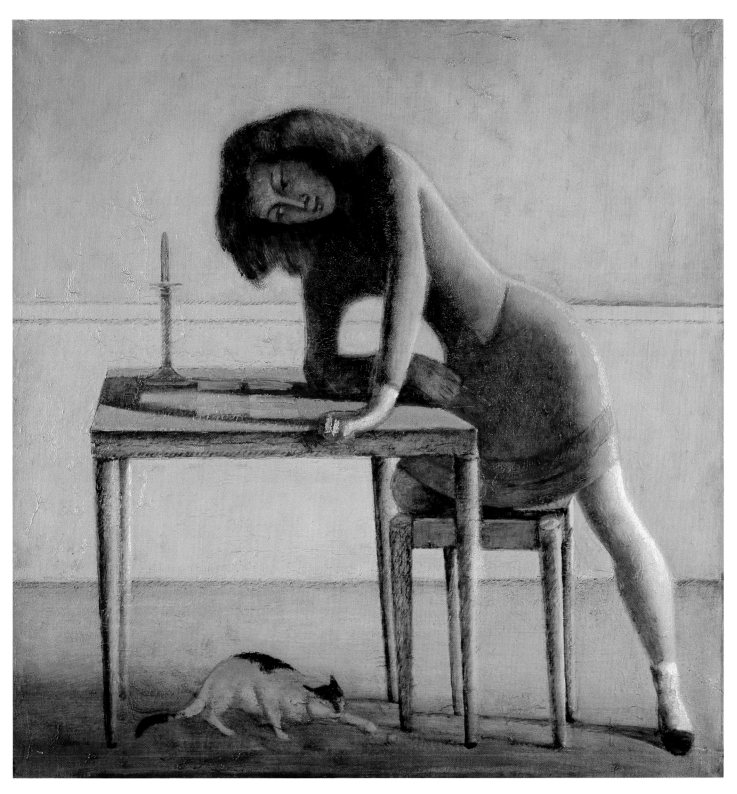

63 *La patience* 1954–55

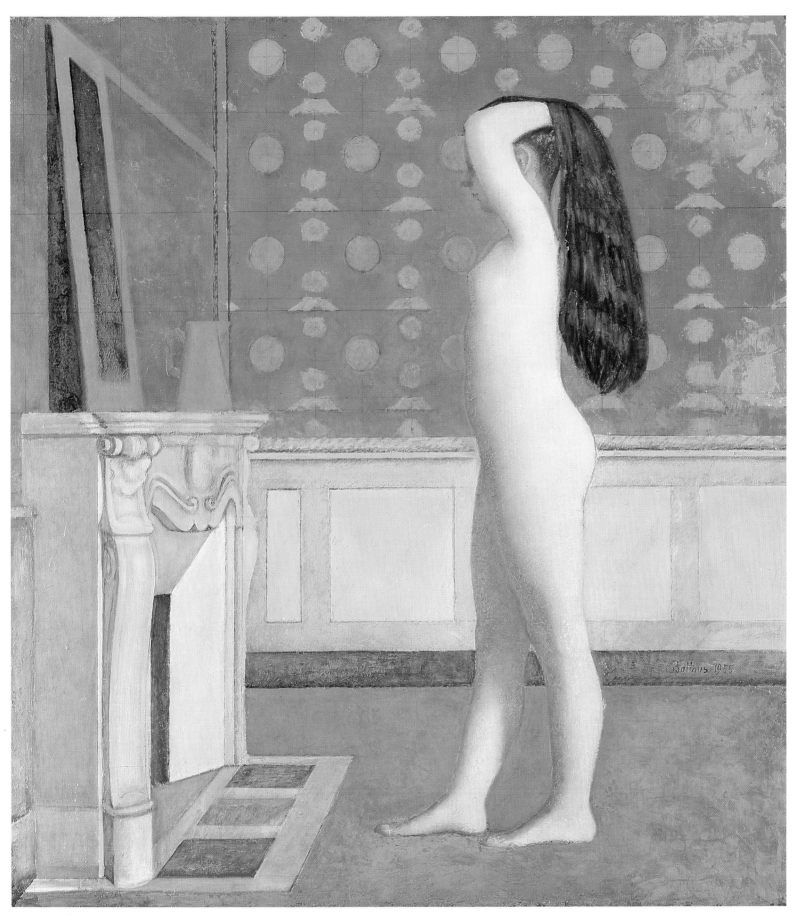

64 *Nu devant la cheminée* 1955

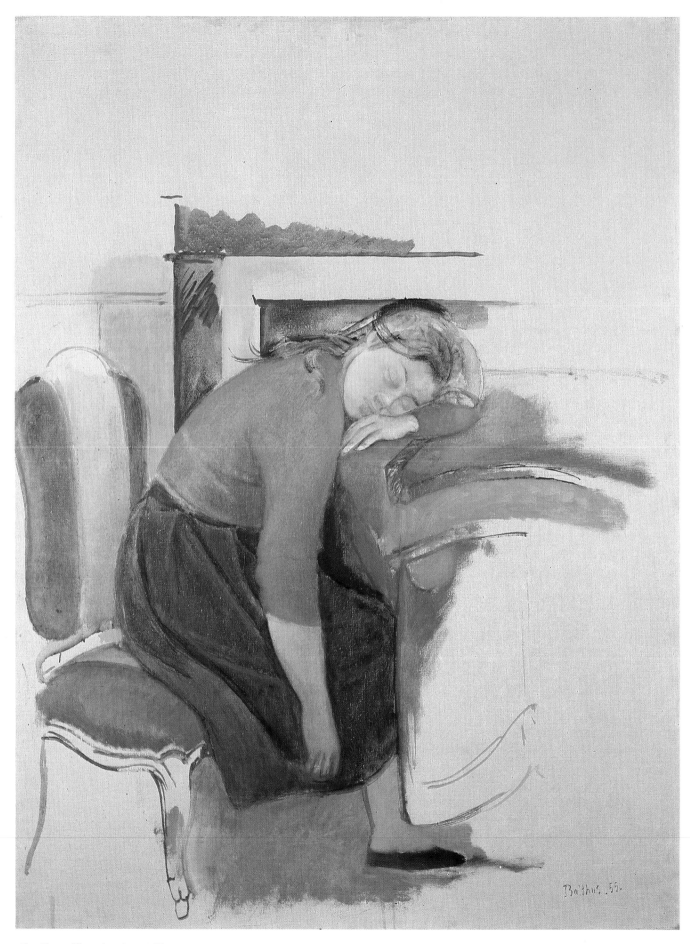

65 *Jeune fille endormie* 1955

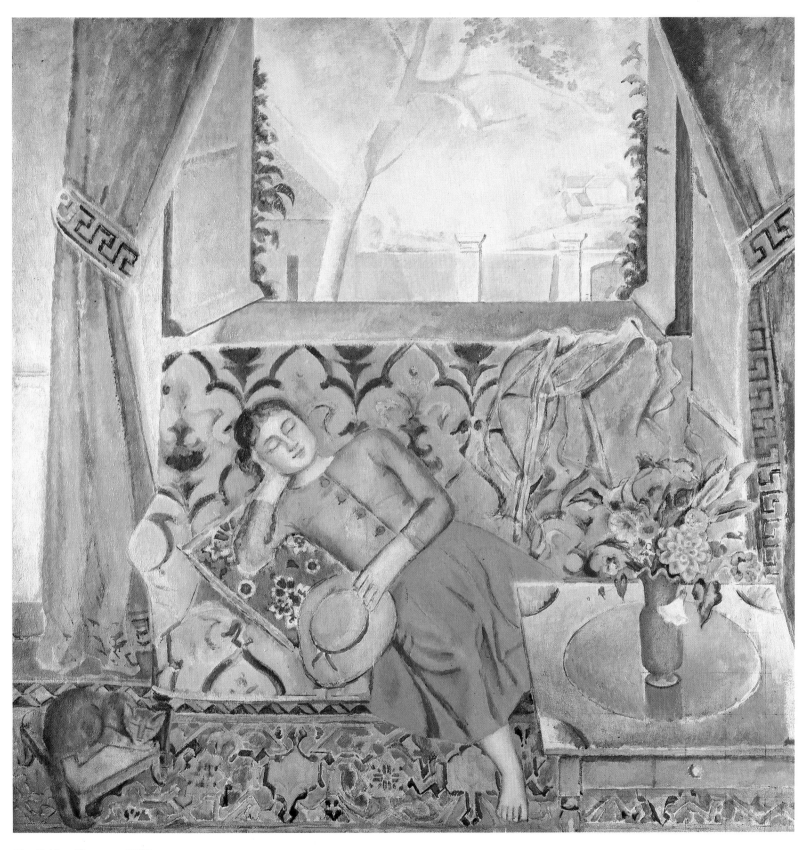

66 *Golden Afternoon* 1957

67 *Nature morte* c. 1956

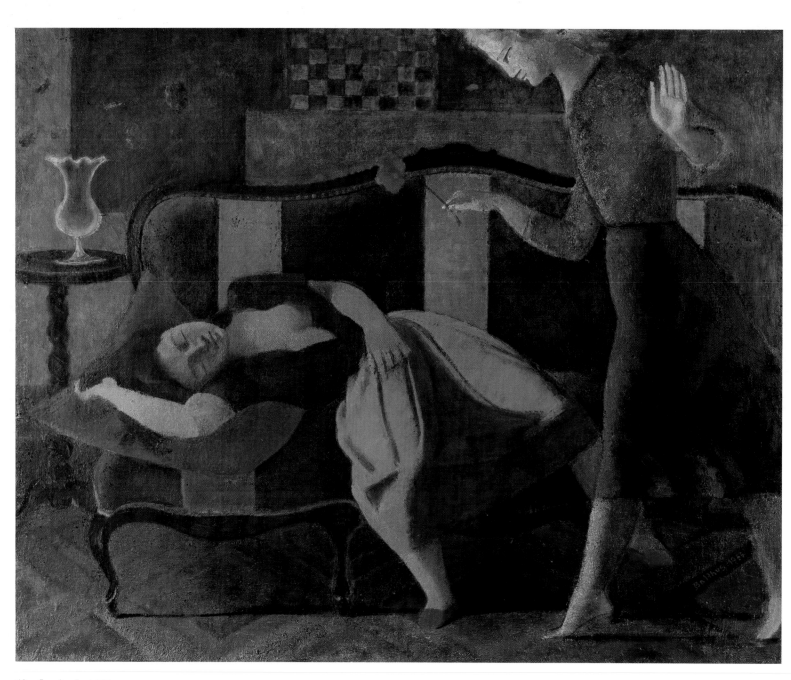

68 *Le rêve I* 1955

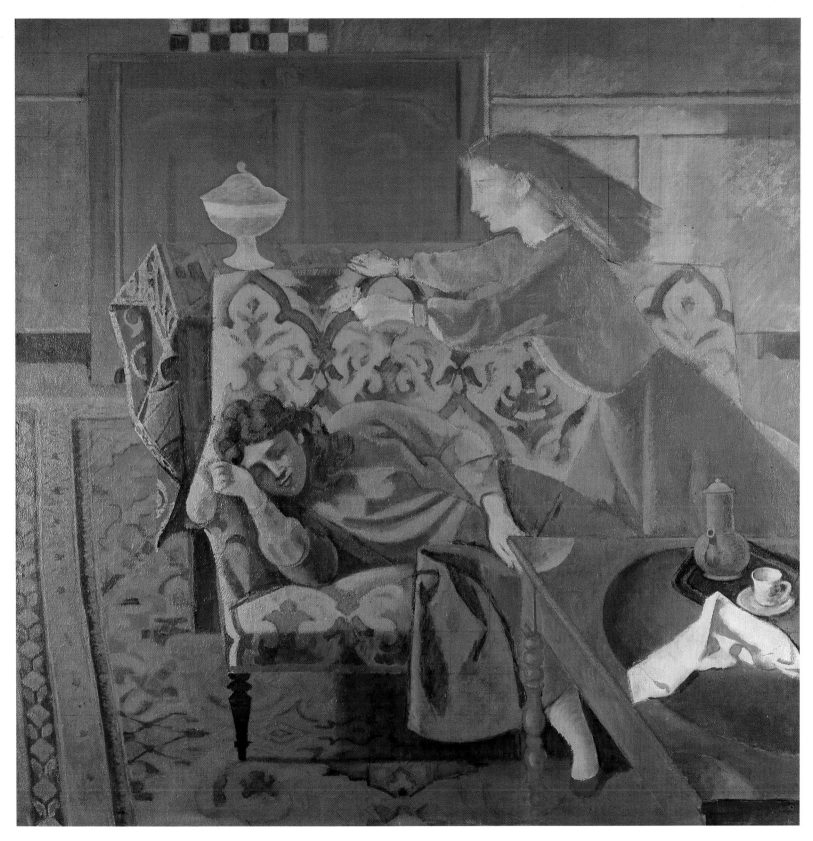

69 *Le rêve II* 1956–57

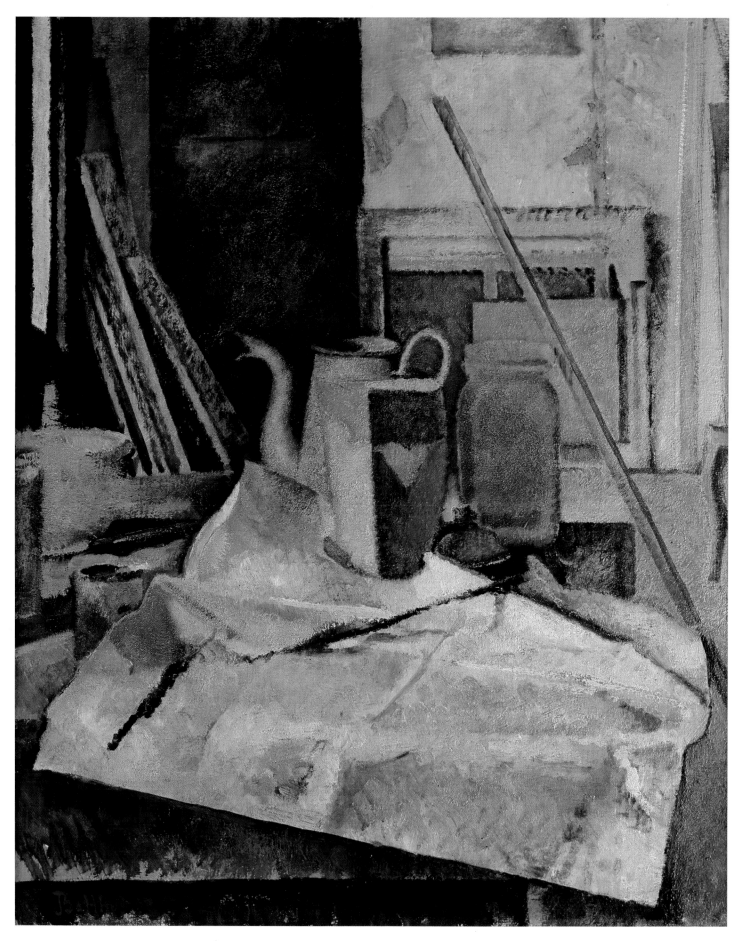

70 *Nature morte dans l'atelier* 1958

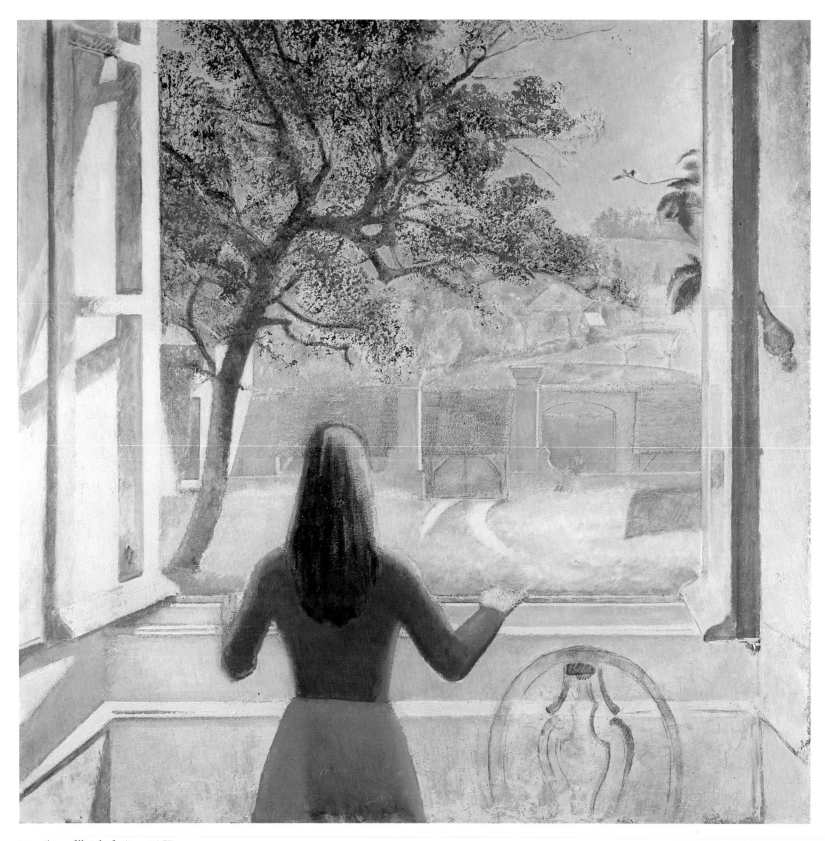

71 *Jeune fille à la fenêtre* 1957

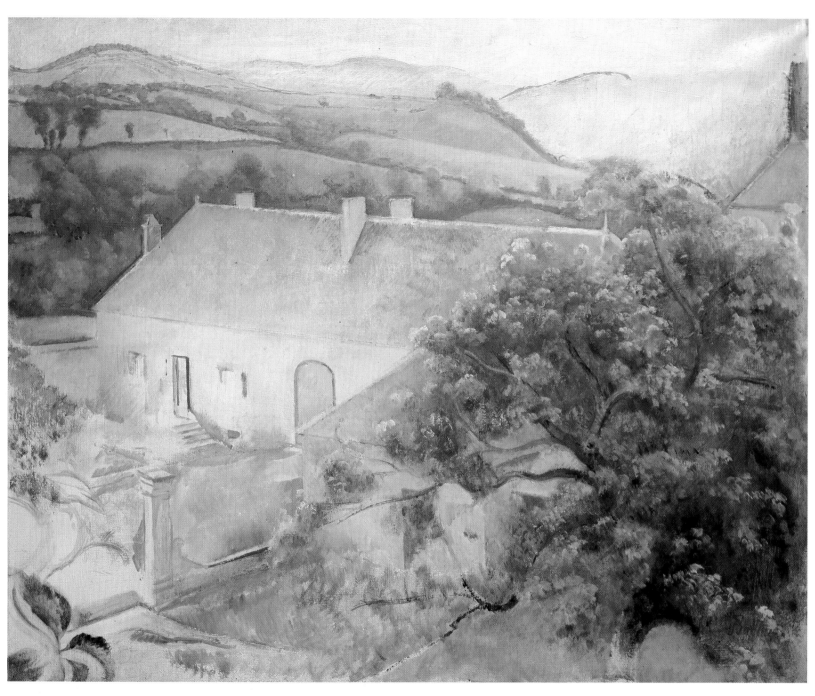

72 *La ferme à Chassy* 1958

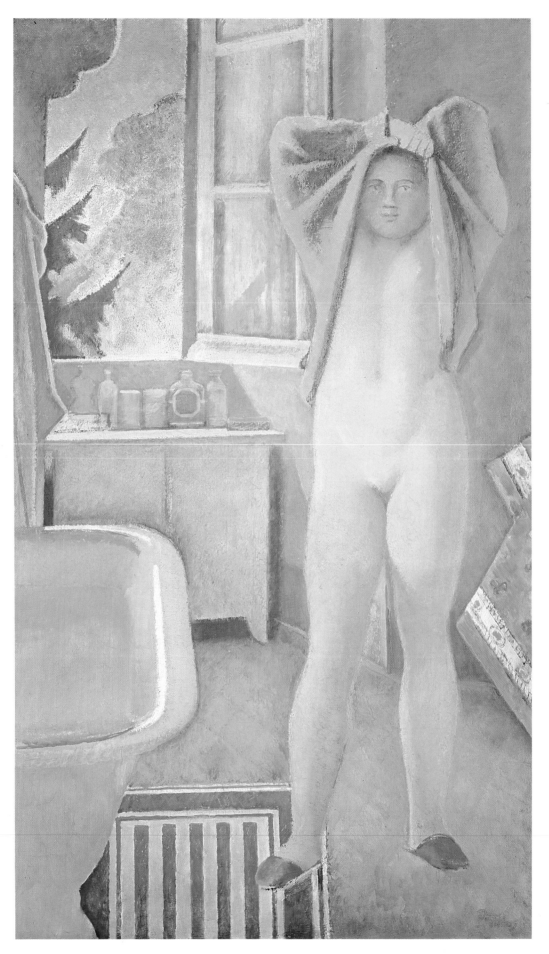

73 *Jeune fille se préparant au bain* 1958

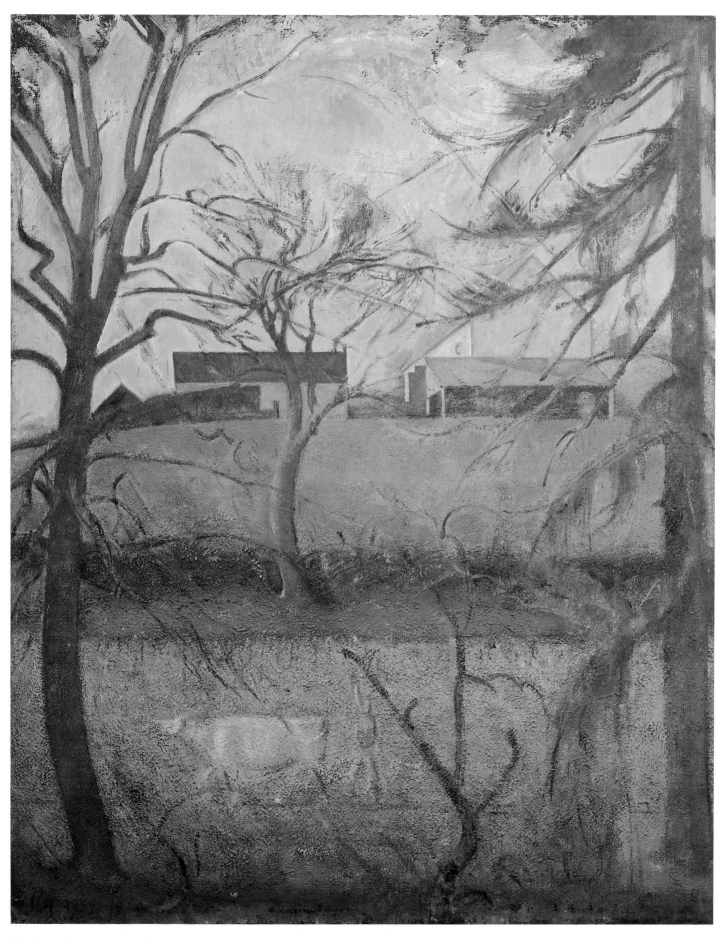

74 *Grand paysage avec vache* 1959–60

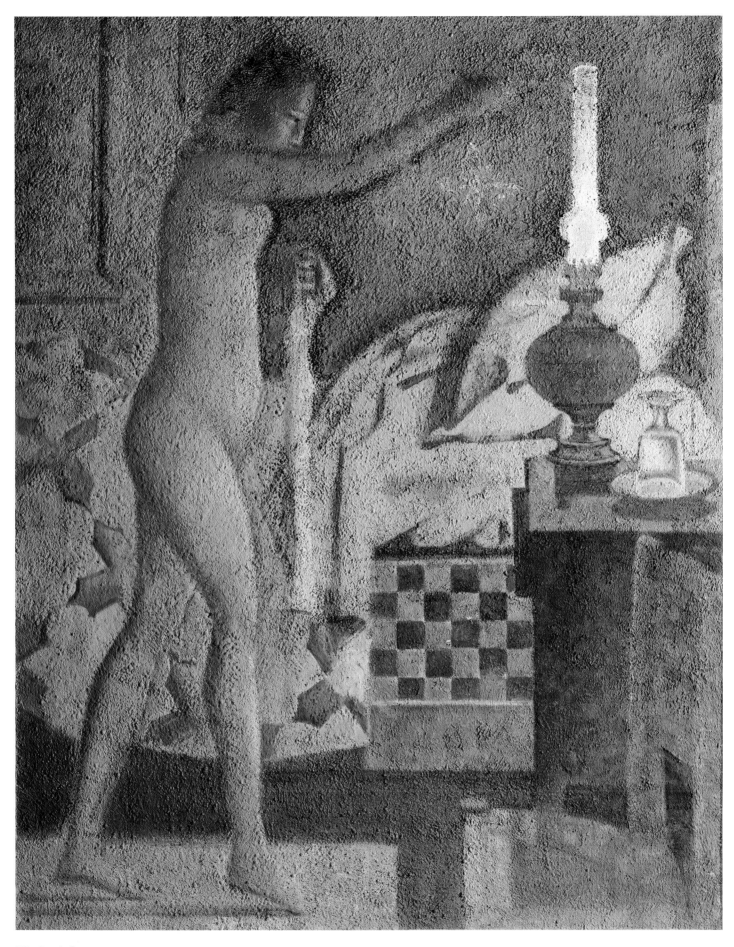

75 *Le phalène* 1959

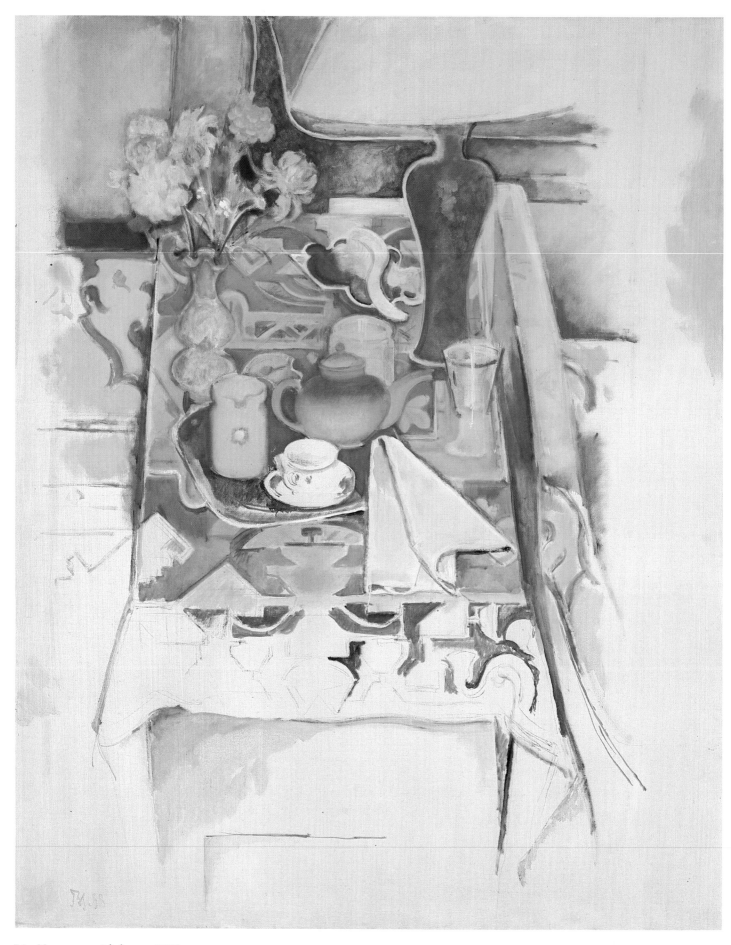

76 *Nature morte à la lampe* 1958

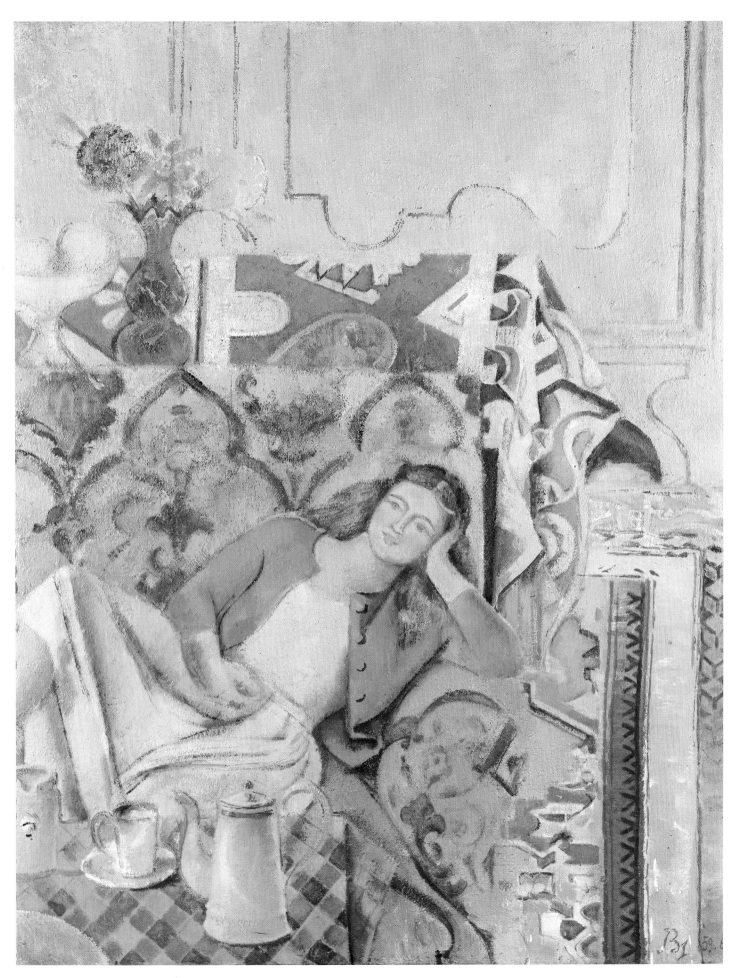

77 *La tasse de café* 1959–60

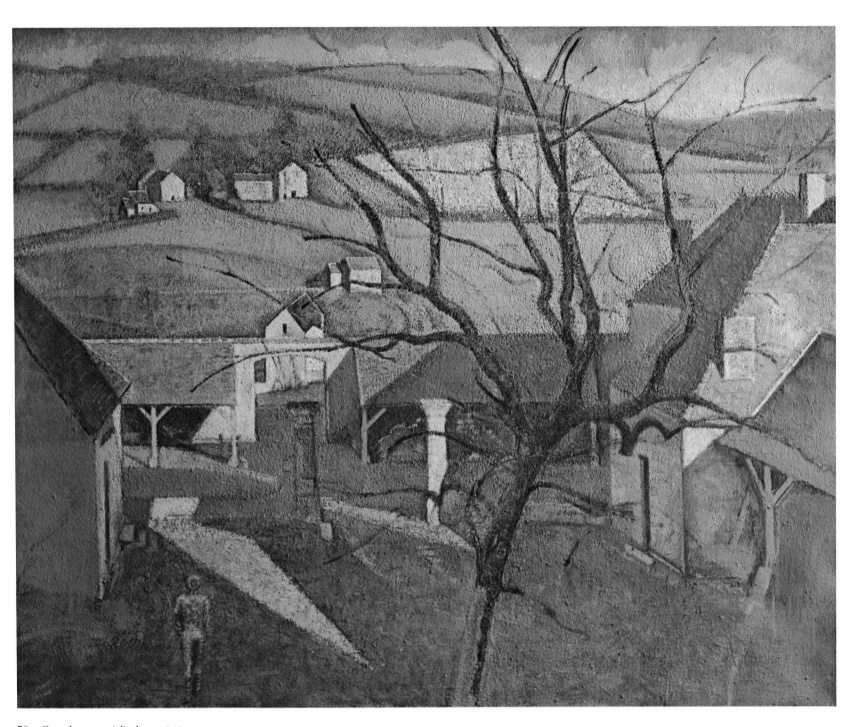

78 *Grand paysage à l'arbre* 1960

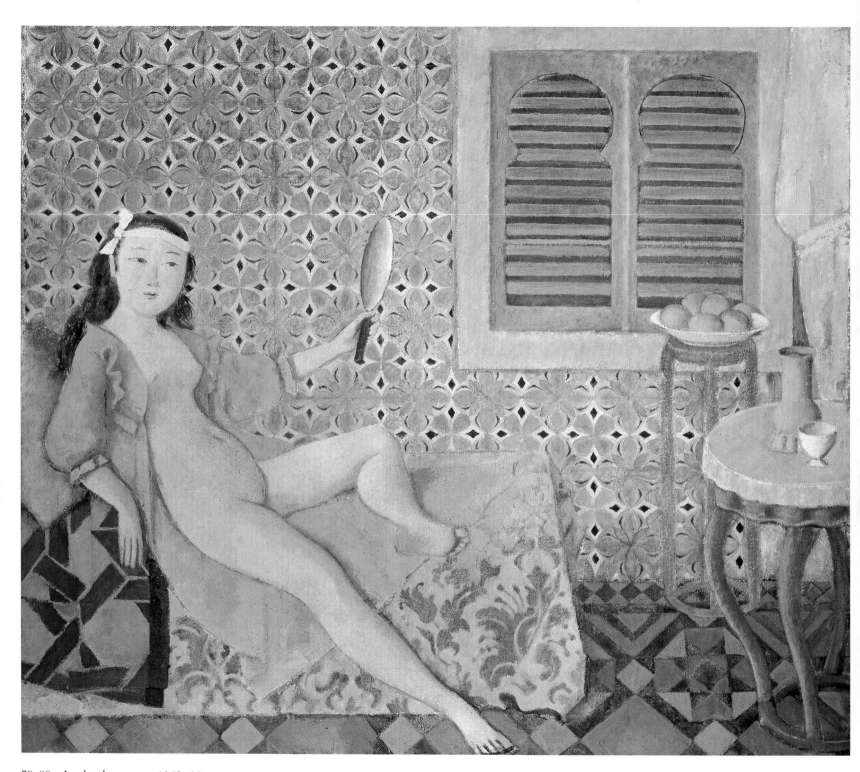

79, 80 *La chambre turque* 1963–66

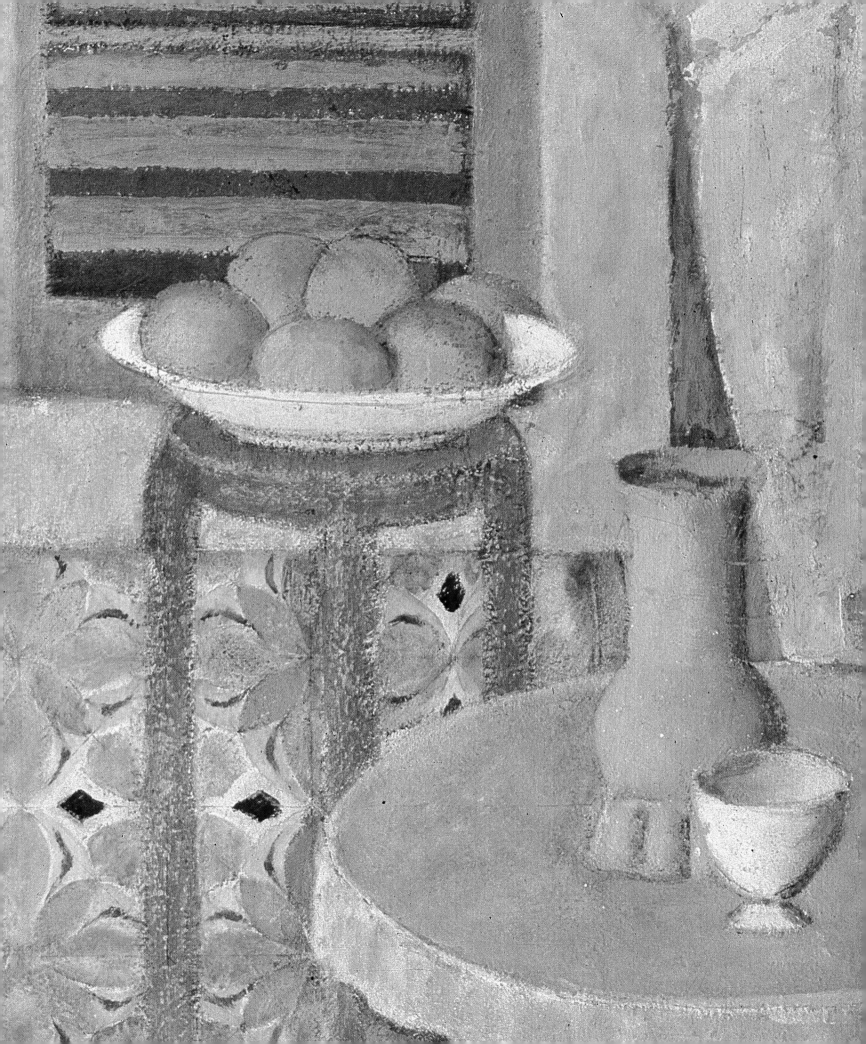

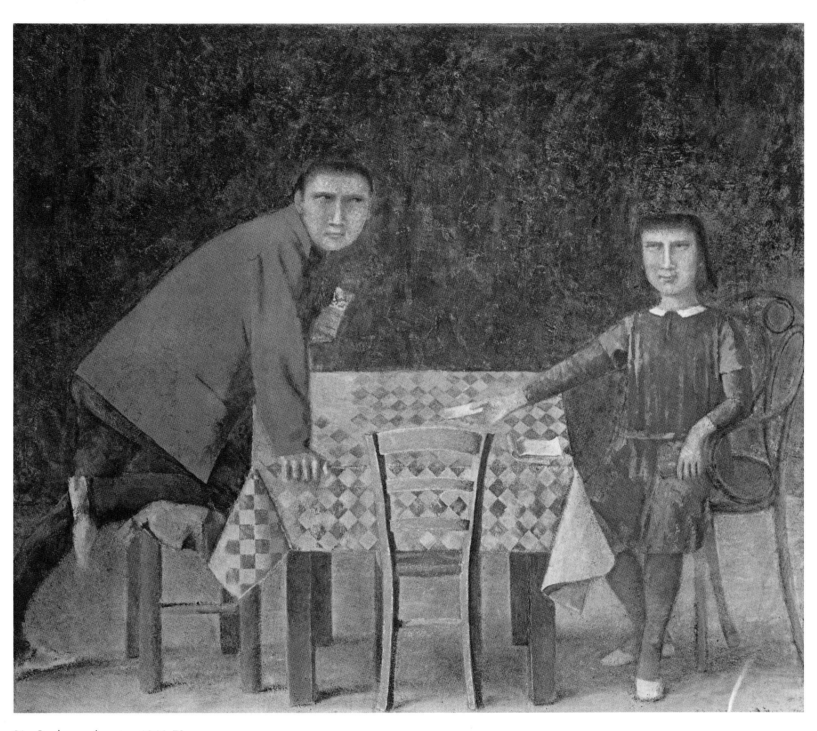

81 *Les joueurs de cartes* 1966–73

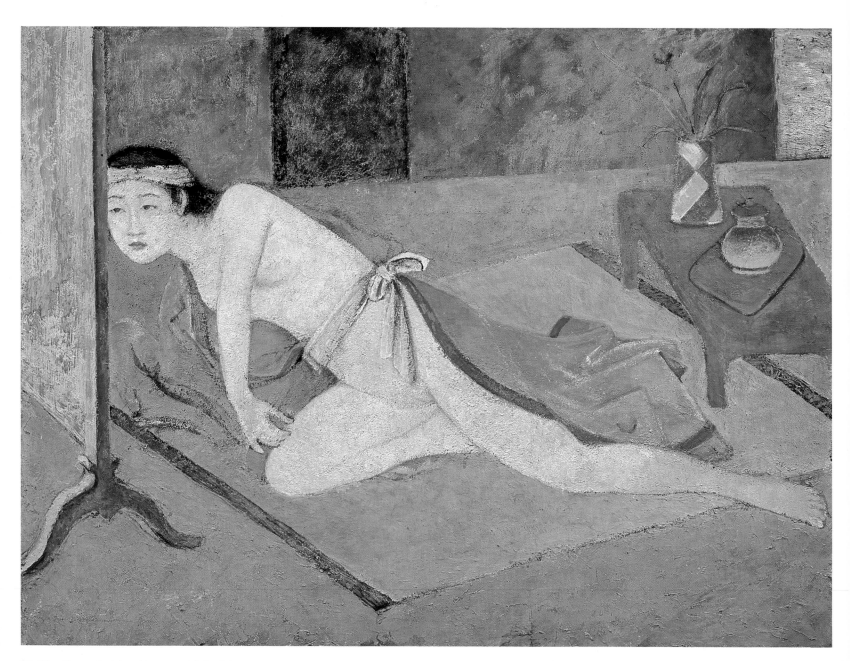

82, 83 *Japonaise à la table rouge* 1967–76

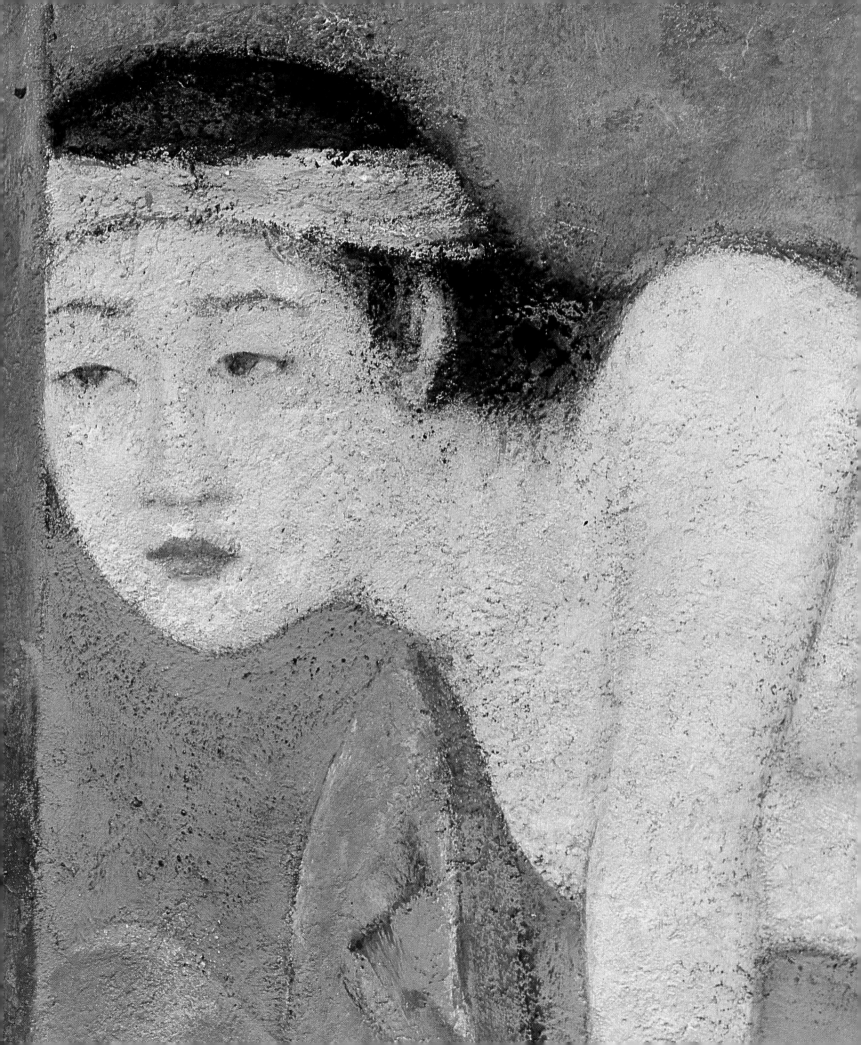

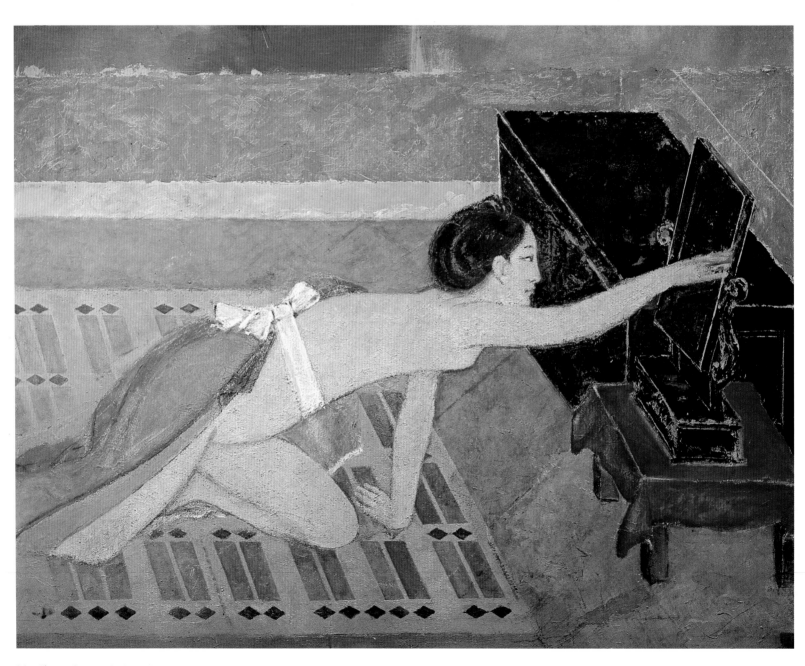

84 *Japonaise au miroir noir* 1967–76

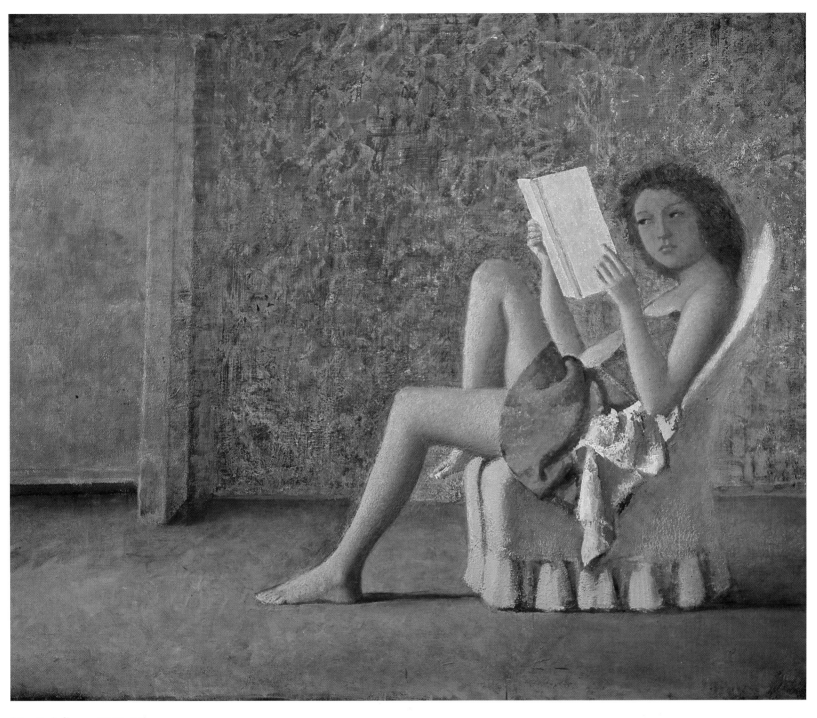

85 *Katia lisant* 1968–76

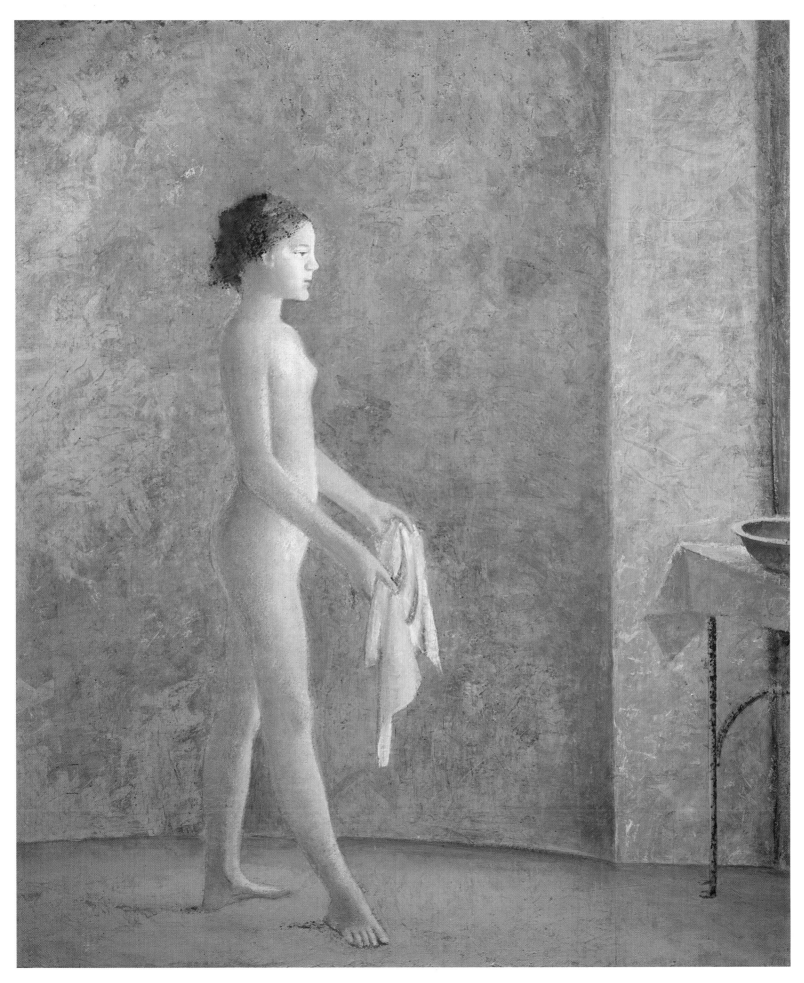

86 *Nu de profil* 1973–77

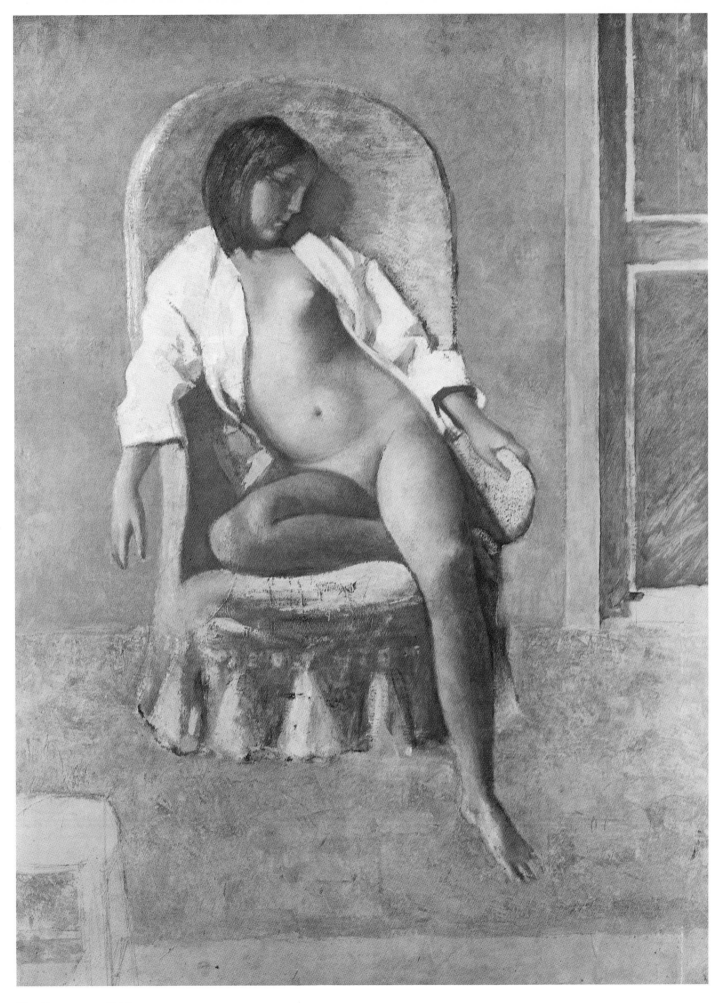

87 *Nu au repos* 1977

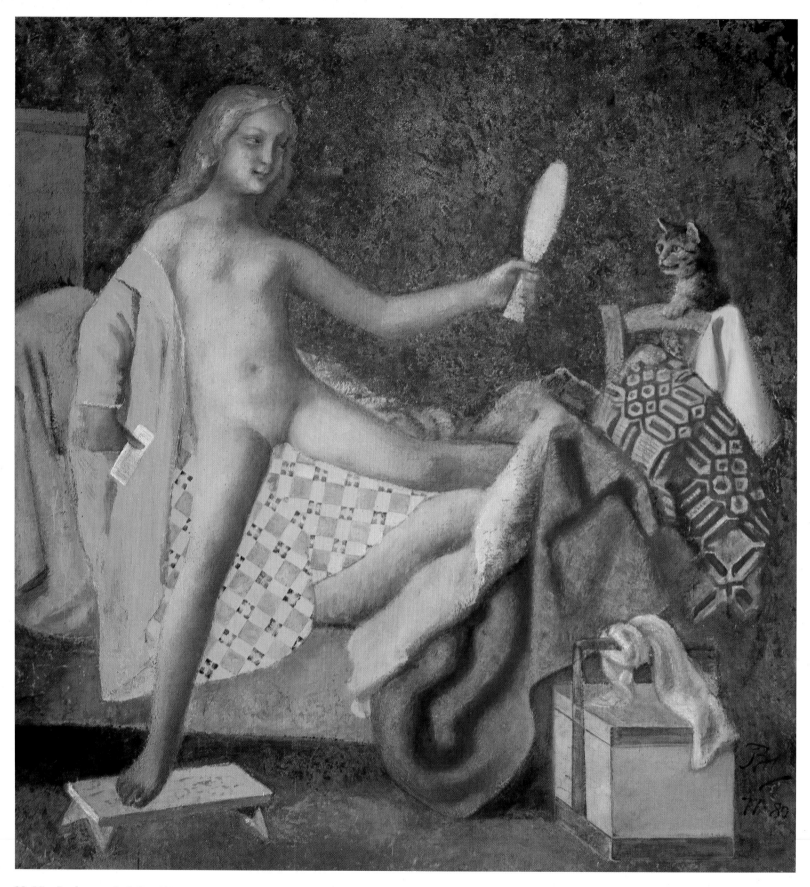

88, 89 *Le chat au miroir I* 1977–80

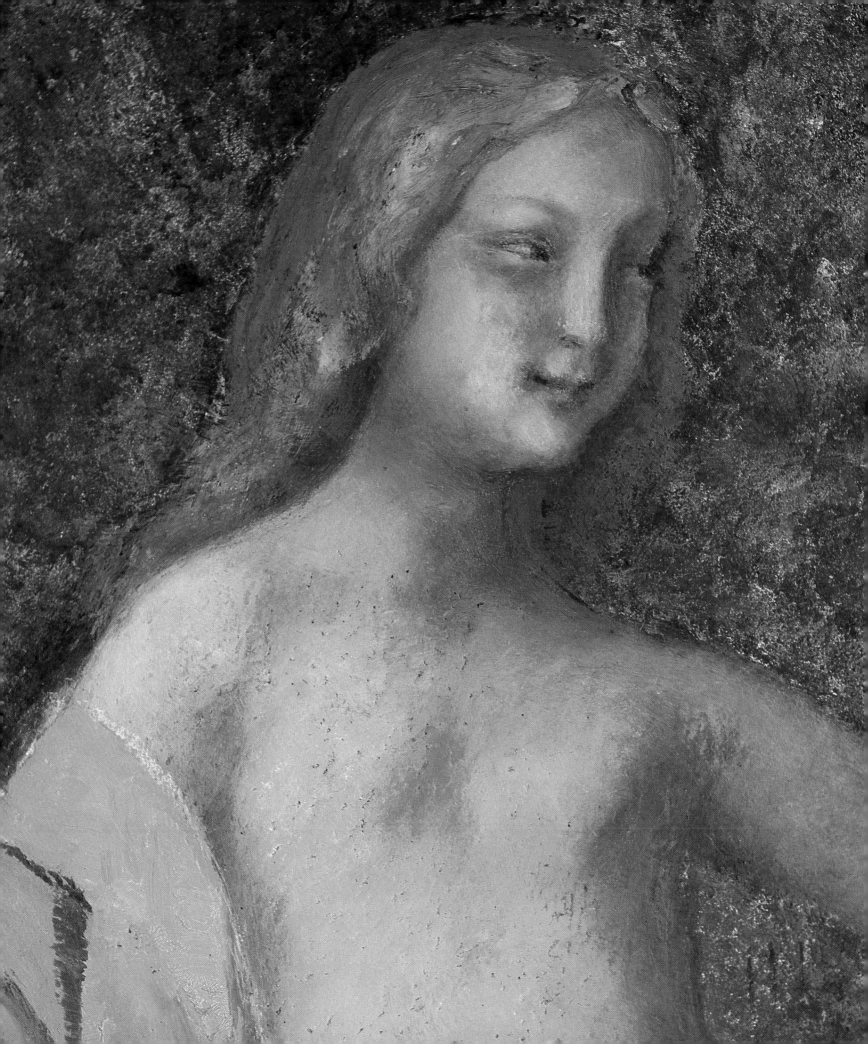

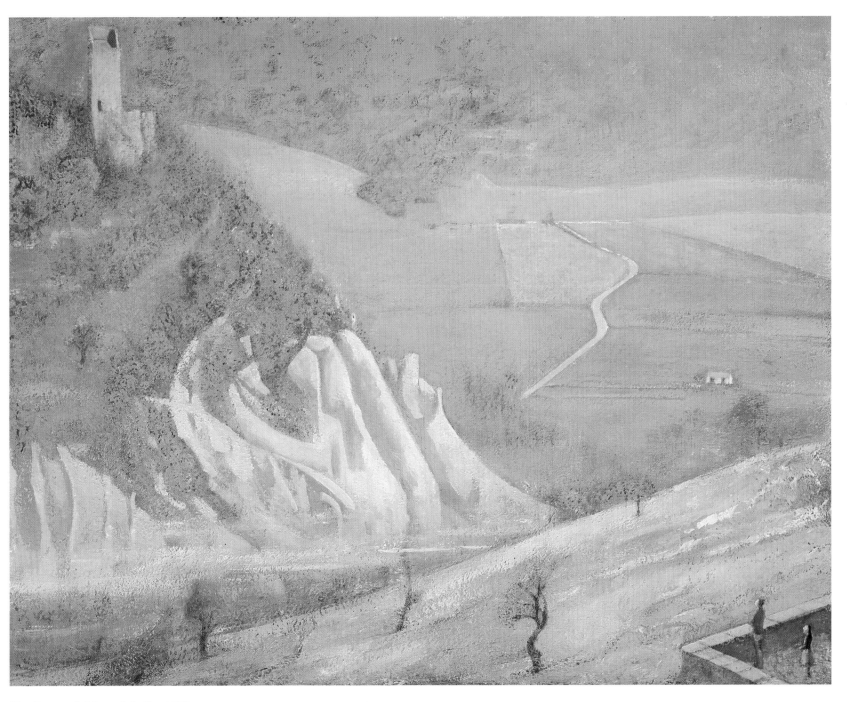

90 *Paysage de Monte Calvello* 1979

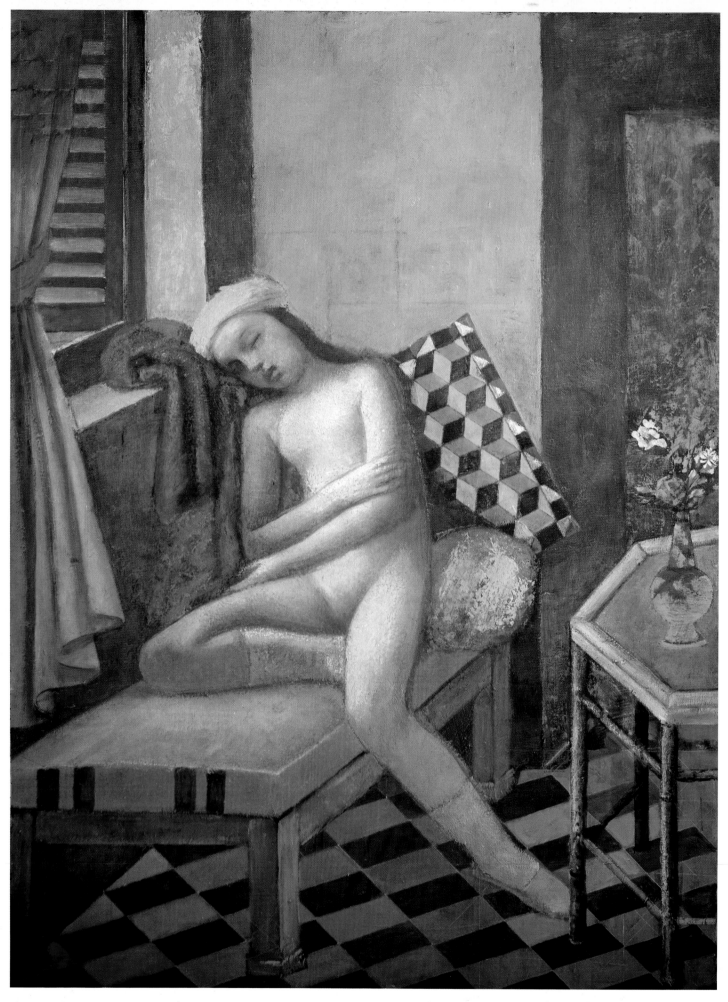

91, 92 *Nu assoupi* 1980

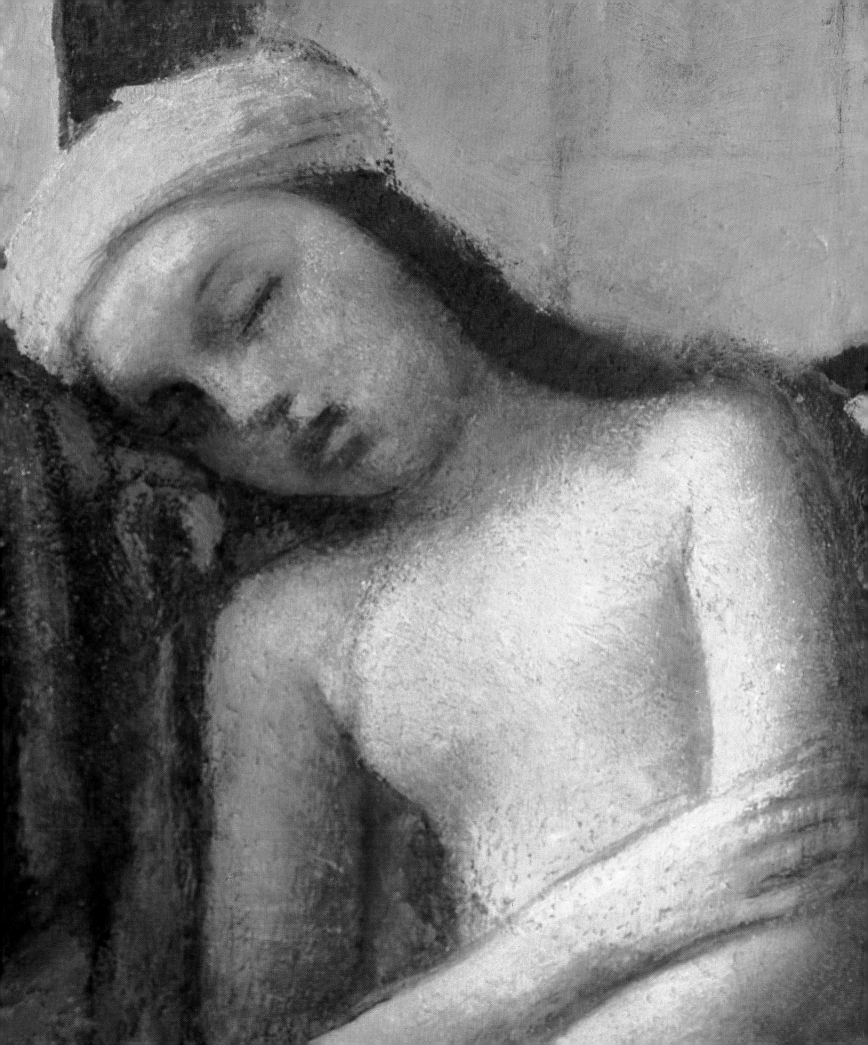

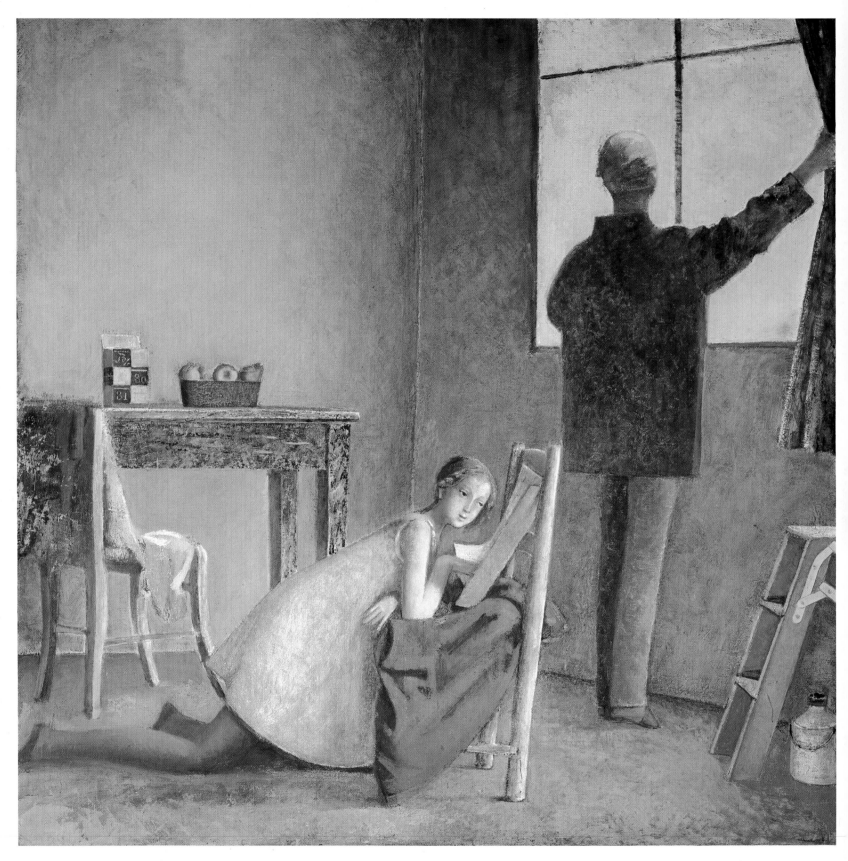

93, 94 *Le peintre et son modèle* 1980–81

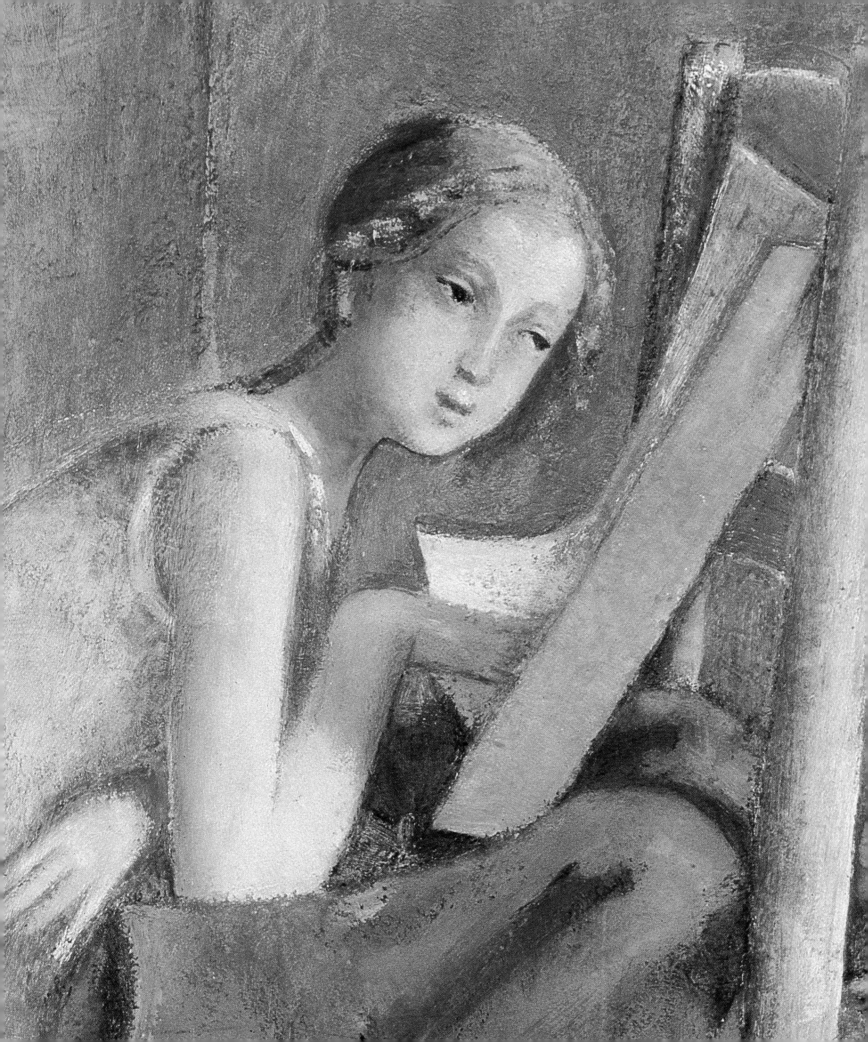

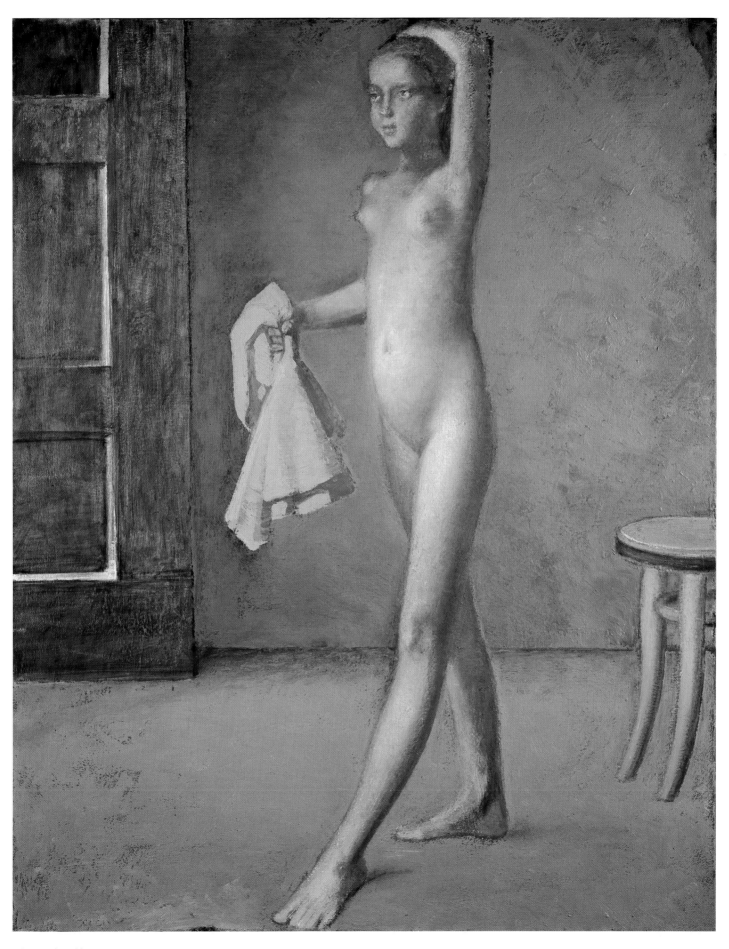

95 *Le drap bleu* 1981–82

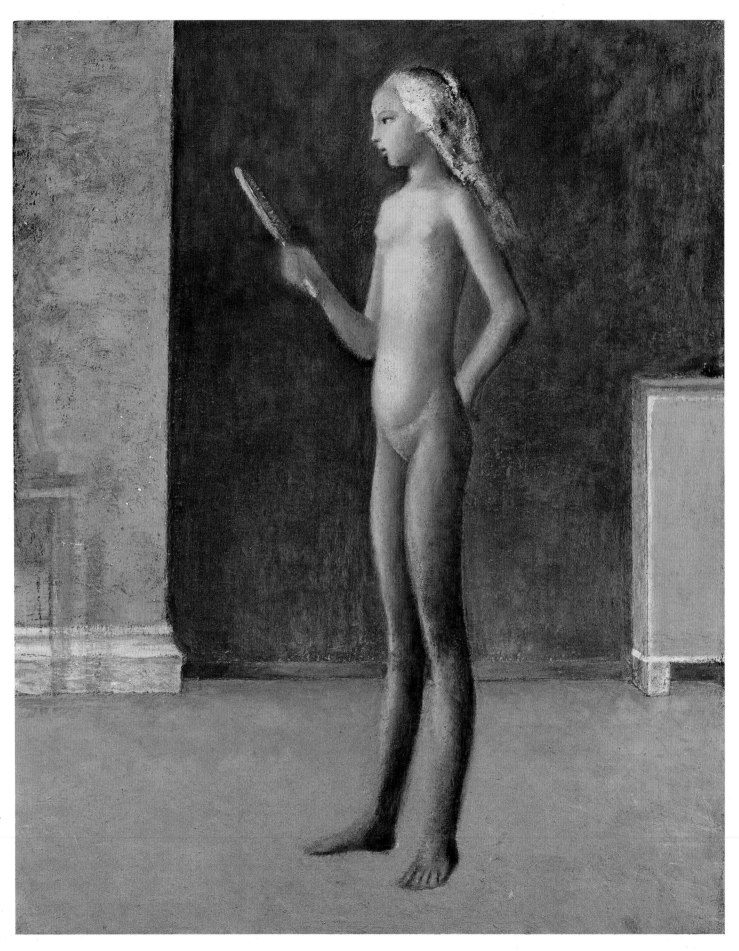

96, 97 *Nu au miroir* 1981–83

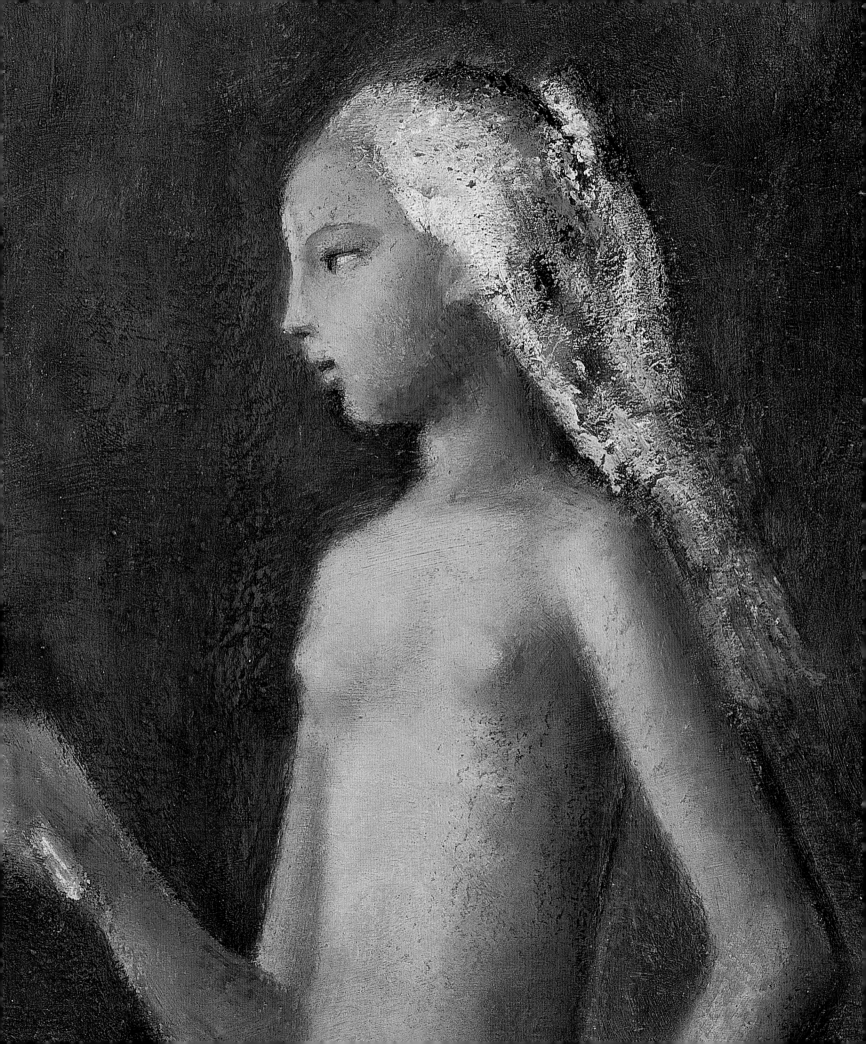

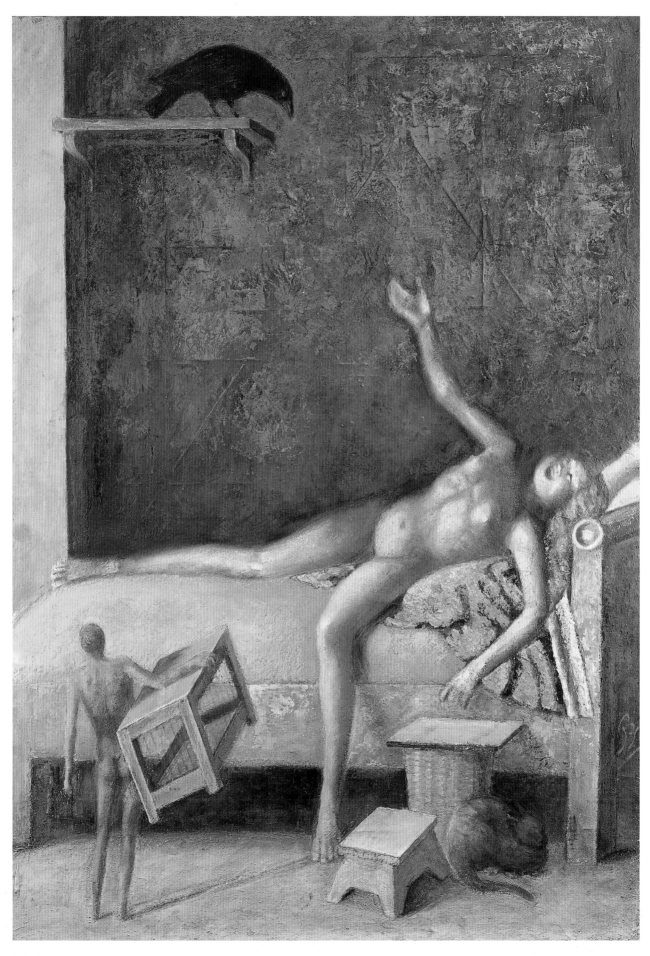

98 *Grande composition au corbeau* 1983–86

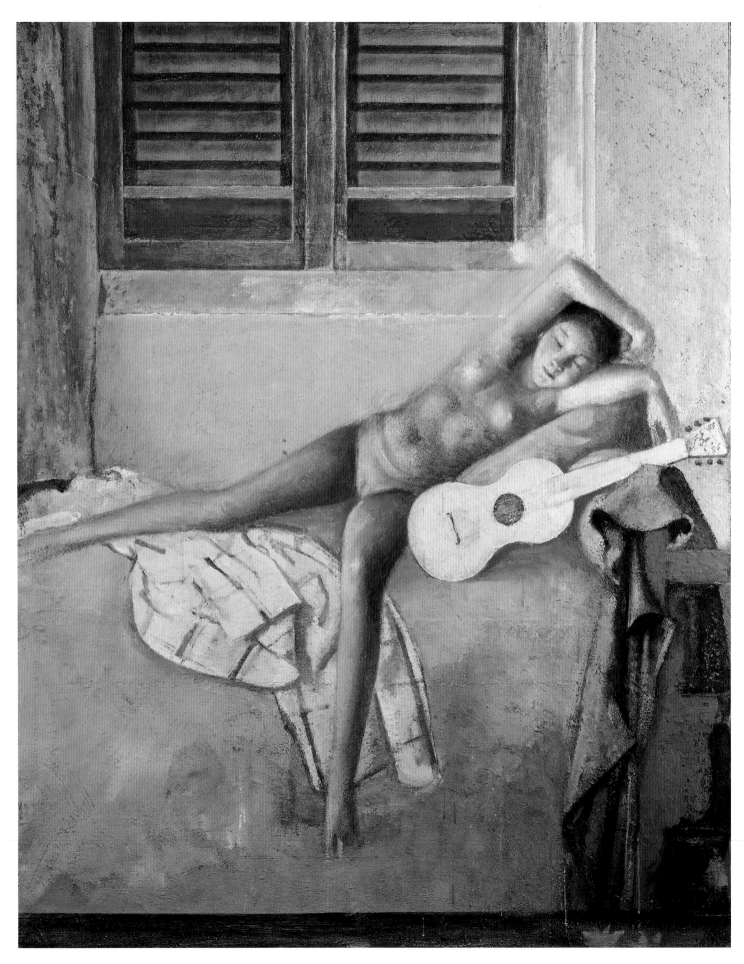

99, 101 *Nu à la guitare* 1983–86

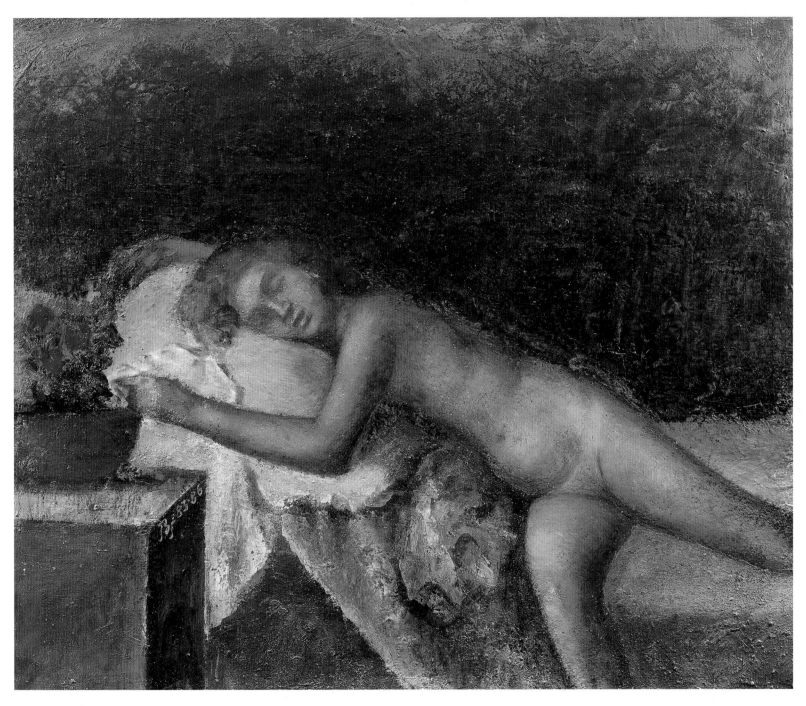

100 *Nu couché* 1983–86

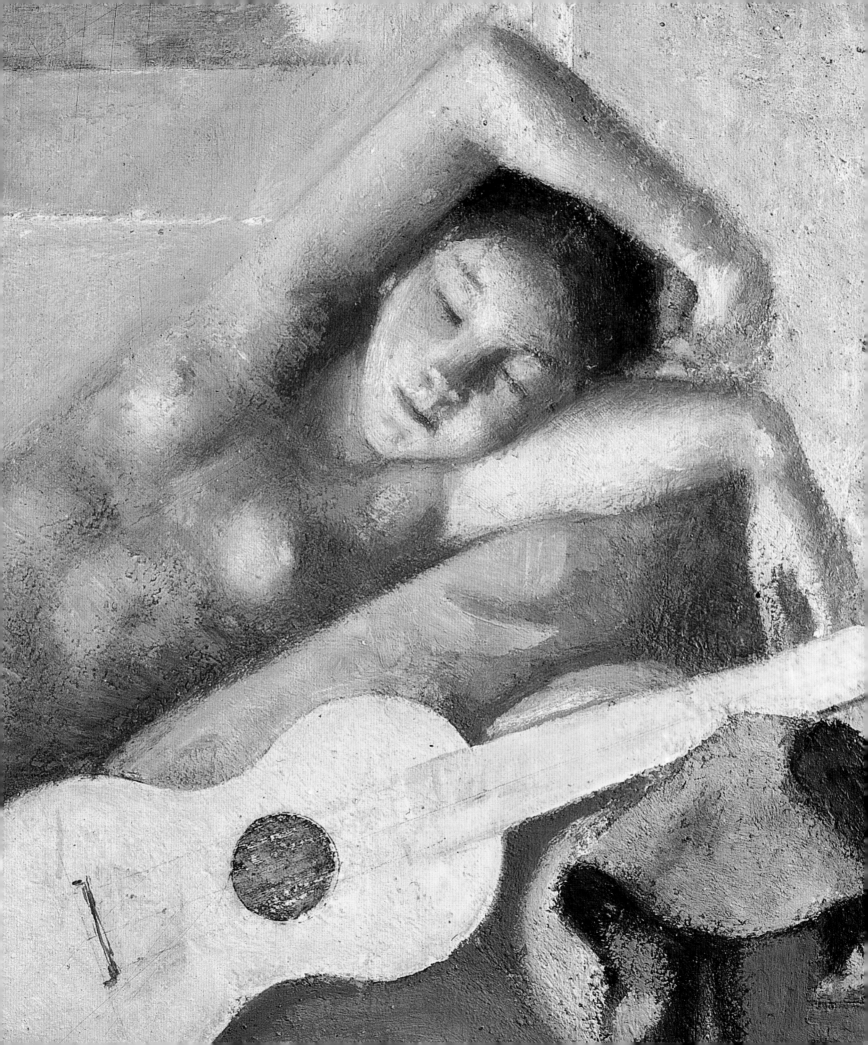

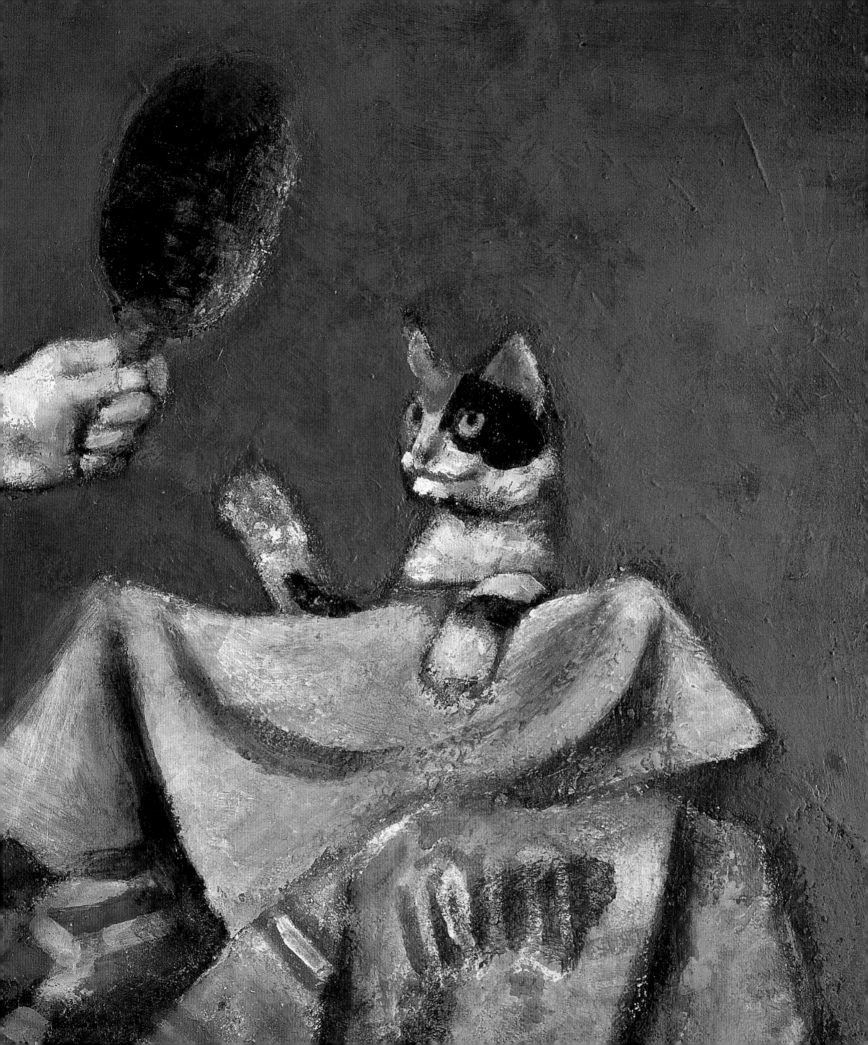

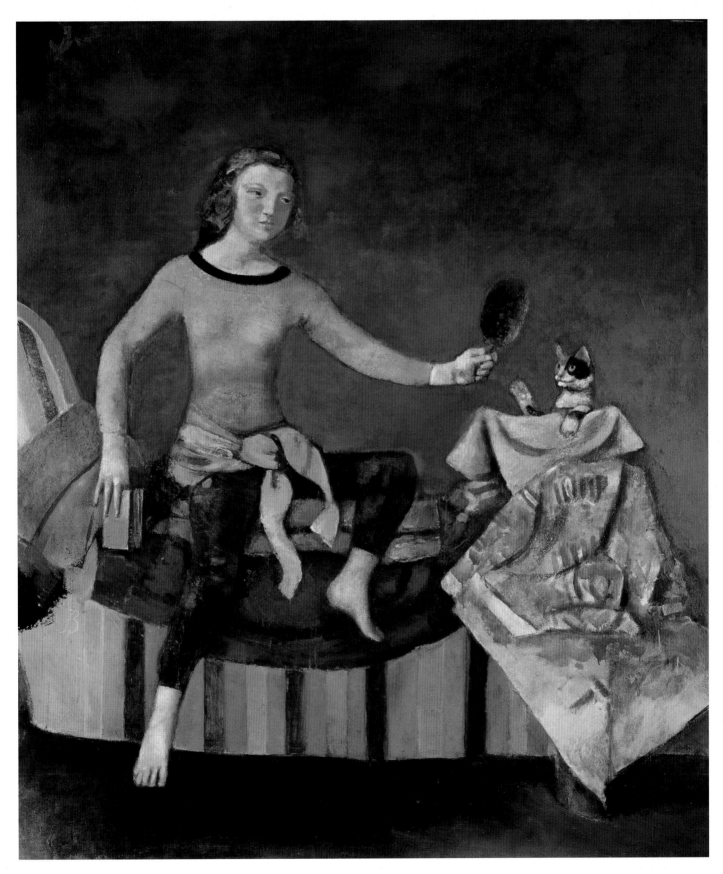

102, 103 *Le chat au miroir II* 1986–89

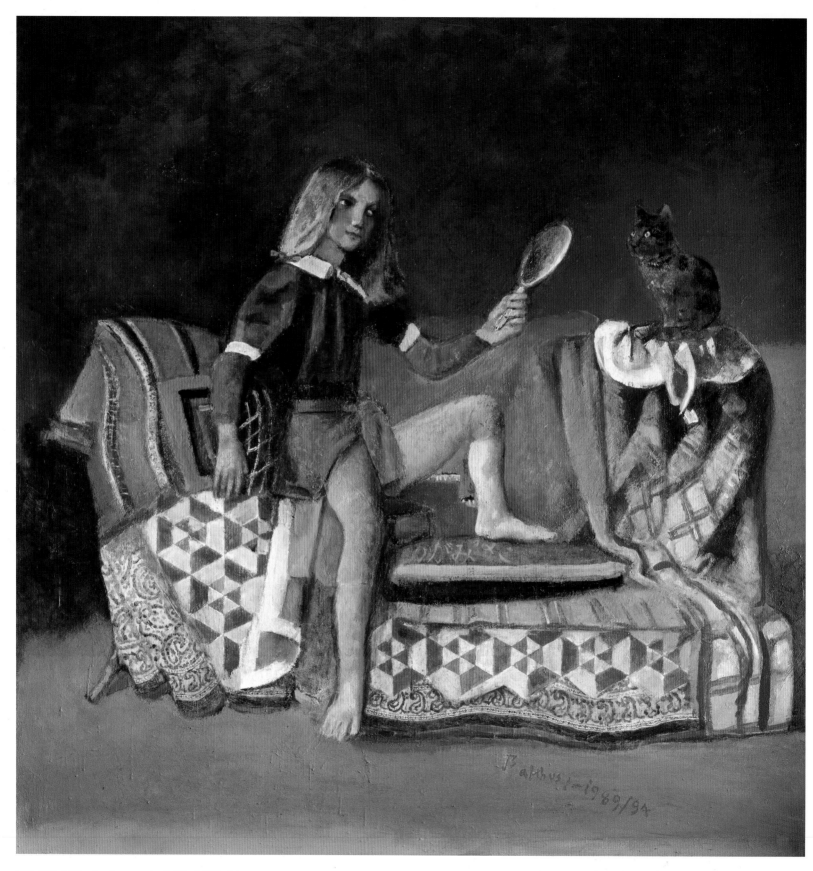

104, 105, 108 *Le chat au miroir III* 1989–94

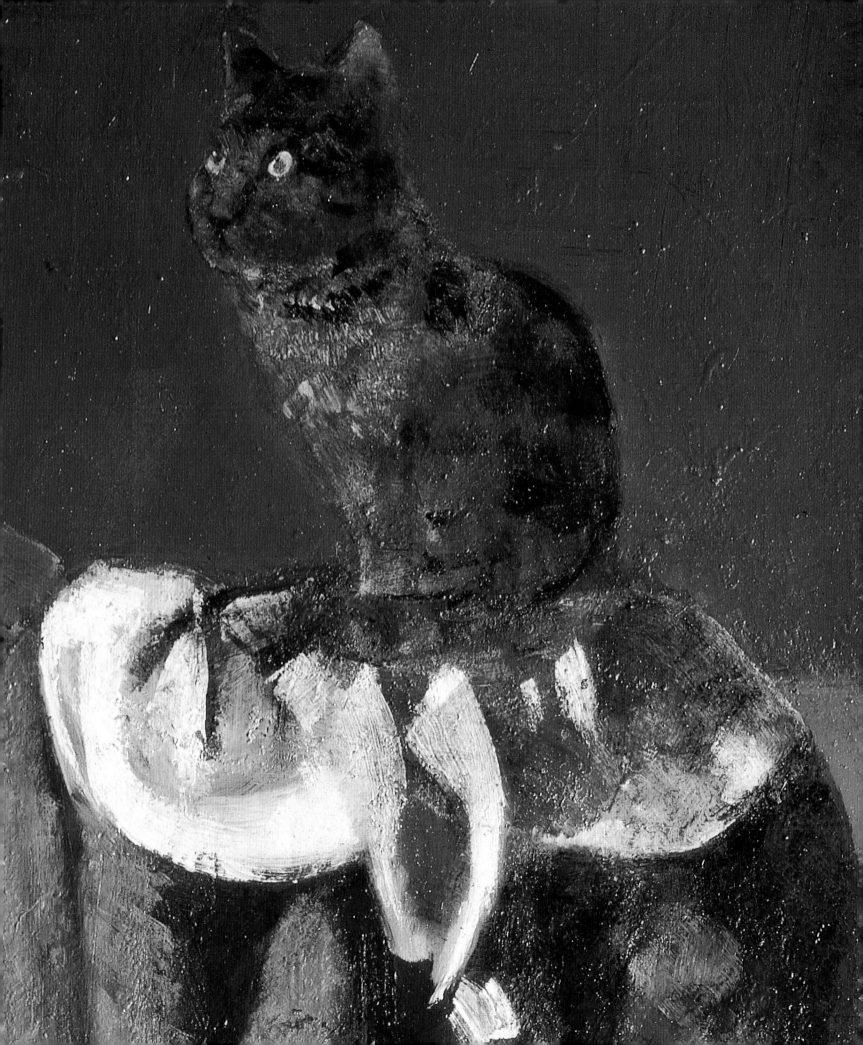

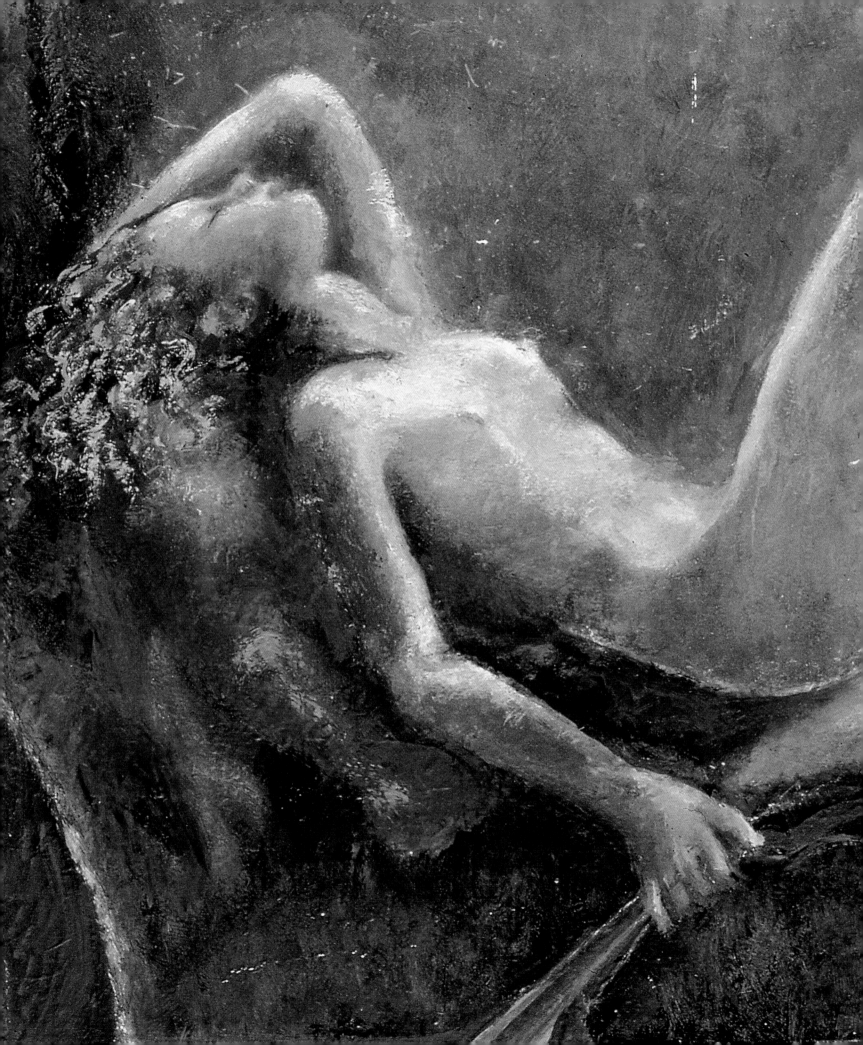

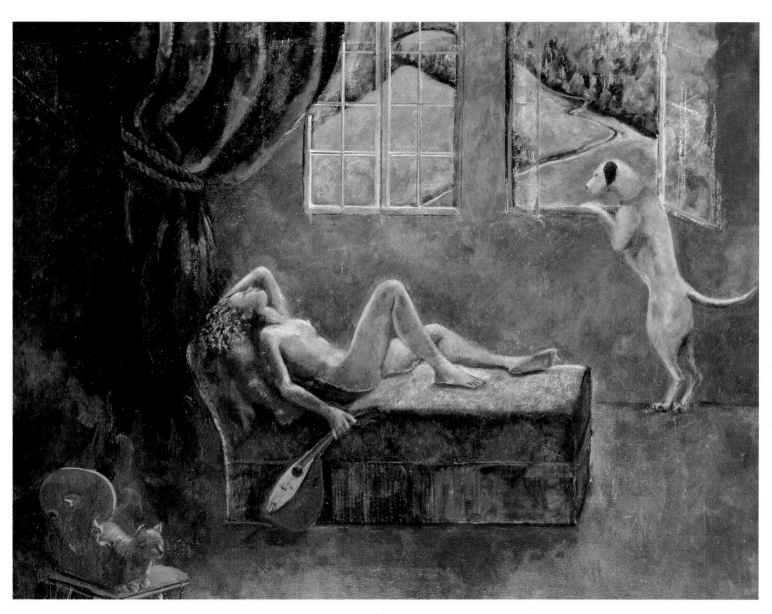

106, 107 *L'attente* 1995–2001

LIST OF WORKS
A N D
BIOGRAPHICAL NOTES

Measurements are given in centimetres and inches, height before width; works are presented in roughly chronological order. Please also note that the practice of listing media such as 'casein tempera on canvas' instead of 'oil on canvas' is misleading, as it is one of several materials used in the preparations of the canvas. 'Oil on canvas' encompasses all such materials.

PHOTOGRAPHS

I
Portrait by Man Ray, 1933
(© TMR/ADAGP, Paris,
1996, Collection L. Treillard)

II
Outside Château de Chassy,
France, by Loomis Dean, 1956
(Time Life Magazine/© Time
Warner)

III–V
Balthus's studio at Villa Medici,
Rome, 1973, by Giorgio Soavi

VI, VII
At Le Grand Chalet, Switzerland,
1991, by Henri Cartier-Bresson

VIII
At Le Grand Chalet, Switzerland,
1994, by Martin Summers

PAINTINGS

1 *Autoportrait* (detail)
 (Self-portrait)
 1940
 Oil on canvas
 44 × 32 (17³/₈ × 12⁵/₈)
 Author's collection
 Photo Joel von Allmen

2 *Le Pont Neuf*
 c. 1927
 Oil on canvas
 Photo Toninelli, Rome, courtesy of
 the artist

3 *Café de l'Odéon*
 1928
 Oil on canvas
 100 × 79 (39³/₈ × 31)
 Private collection
 Photo Jacqueline Hyde

4 *Jardin du Luxembourg*
 1928
 Oil on canvas
 46 × 55 (18¹/₈ × 21⁵/₈)
 Private collection
 Photo G. Howald, Kirchlindach-
 Bern

5 *Les quais*
 (The Embankment)
 1929
 Oil on canvas
 71 × 58 (28¹/₂ × 23³/₄)
 Collection Pierre Matisse
 Photo Pierre Matisse Gallery

6 *La rue*
 (The Street)
 1929
 Oil on canvas
 129.5 × 162 (51 × 63³/₄)
 Private collection
 Photo Pierre Matisse Gallery

7 *La rue*
 (The Street)
 1933–35
 Oil on canvas
 195 × 240 (76³/₄ × 94¹/₂)
 Collection, The Museum of
 Modern Art, New York. James
 Thrall Soby Bequest

8 Detail of *La rue*

9 Detail of *La rue*

10 *Alice*
 1933
 Oil on canvas
 112 × 161 (44 × 63¹/₂)
 Private collection, Switzerland
 Photo Marlborough Fine Art
 (London) Ltd

11 *La toilette de Cathie*
 (Cathy Dressing)
 1933
 Oil on canvas
 65 × 59 (25⁵/₈ × 23¹/₄)
 Musée National d'Art
 Moderne, Centre Georges
 Pompidou, Paris
 Photo Jacqueline Hyde

12 *La famille Mouron-Cassandre*
 1935
 Oil on canvas
 72 × 72 (28³/₈ × 28³/₈)
 Private collection
 Photo Maurice Aeschimann

13 Detail of *La famille Mouron-
 Cassandre*

14 *Lelia Caetani*
 1935
 Oil on canvas
 116 × 88 (45¹/₂ × 34¹/₂)
 Private collection
 Photo Pierre Matisse
 Foundation

15 *La montagne*
 (The Mountain)
 1935–37
 Oil on canvas
 250 × 365.1 (98¹/₂ × 143³/₄)
 The Metropolitan Museum
 of Art, New York, Purchase,
 Gifts of Mr and Mrs Nate
 B. Springold and Nathan
 Cummings, Rogers Fund
 and The Alfred N. Punnett
 Endowment Fund, by exchange,
 and Harris Brisbane Dick Fund,
 1982
 Photo Pierre Matisse Gallery

16 Detail of *La montagne*

17 *La leçon de guitare*
 (The Guitar Lesson)
 1934
 Oil on canvas
 161 × 138.5 (63³/₈ × 54¹/₂)
 Private collection

18 *André Derain*
1936
Oil on wood
112.7 × 72.4 (44³⁄₈ × 28¹⁄₂)
Collection, The Museum of
Modern Art, New York.
Acquired through the Lillie
P. Bliss Bequest

19 *Thérèse*
1938
Oil on canvas
100.3 × 81.3 (39¹⁄₂ × 32)
Metropolitan Museum of Art,
gift of Mr and Mrs Allan D.
Emil in honour of William S.
Lieberman, 1987
Photo Pierre Matisse Gallery

20 *Portrait de Thérèse*
1936
Oil on canvas
62 × 71 (24¹⁄₂ × 28)
Private collection, Switzerland
Photo Marlborough Fine Art
(London) Ltd

21 *Portrait de la Vicomtesse de Noailles*
1936
Oil on canvas
135 × 160 (53¹⁄₄ × 63)
Private collection
Photo Jacqueline Hyde

22 *Les enfants*
(The Children)
1937
Oil on canvas
125 × 130 (49¹⁄₄ × 51¹⁄₈)
Musée du Louvre, Paris, donation
Pablo Picasso
Photo Musées Nationaux, Paris

23 *Jeune fille au chat*
(Girl with Cat)
1937
Oil on canvas
88 × 78 (31¹⁄₂ × 34⁵⁄₈)
Collection Mr and Mrs E. A.
Bergman
Photo Pierre Matisse Gallery

24 *Nature morte*
(Still-life)
1937
Oil on wood panel
81 × 100 (31⁷⁄₈ × 39³⁄₈)
Wadsworth Atheneum, Hartford,
Connecticut. The Ella Gallup
Sumner and Mary Catlin Sumner
Collection 1938.272

25 *La jupe blanche*
(The White Skirt)
1937
Oil on canvas
130 × 162 (51¹⁄₈ × 63³⁄₄)
Private collection, Switzerland
Photo Borel-Boissonnas

26 *Portrait d'une jeune fille en costume*
d'amazone
(Portrait of a Young Woman in Riding
Costume)
1932, repainted 1981
Oil on canvas
72 × 52 (28³⁄₈ × 20¹⁄₂)
Author's collection
Photo Joel von Allmen

27 Detail of *Portrait d'une jeune fille en*
costume d'amazone

28 *Joan Miró et sa fille Dolorès*
(Joan Miró and his Daughter Dolorès)
1937–38
Oil on canvas
130.2 × 88.9 (51¹⁄₄ × 35)
The Museum of Modern Art, New
York. Abby Aldrich Rockefeller
Fund, 1938

29 *La victime*
(The Victim)
1938
Oil on canvas
133 × 220 (53²⁄₈ × 86⁵⁄₈)
Private collection
Photo Jacqueline Hyde

30 *Thérèse rêvant*
(Thérèse Dreaming)
1938
Oil on canvas
150.5 × 130.2 (59¹⁄₄ × 51¹⁄₄)

Private collection
Photo Pierre Matisse Gallery

31 Detail of *Autoportrait*

32 *Autoportrait*
(Self-portrait)
1940
Oil on canvas
44 × 32 (17³⁄₈ × 12³⁄₈)
Private collection
Photo Joel von Allmen

33 *Larchant*
1939
Oil on canvas
130 × 162 (51 × 63³⁄₄)
Private collection
Photo courtesy Electa

34 *Le Gottéron*
1943
Oil on canvas
115 × 99.5 (45¹⁄₄ × 39¹⁄₈)
Collection P. Y. Chichong, Tahiti

35 *Vernatel (Paysage aux boeufs)*
Vernatel (Landscape with oxen)
1941–42
Oil on canvas
72 × 100 (28³⁄₄ × 39³⁄₈)
Private collection

36 *Le cerisier*
(The Cherry Tree)
1940
Oil on canvas
92 × 73 (36¹⁄₄ × 28³⁄₄)
Collection Mr and Mrs Henry
Luce III
Photo Galerie Claude Bernard

37 *Jeune fille et nature morte*
(Still-life with Girl)
1942
Oil on wood
73 × 92 (28³⁄₄ × 36¹⁄₄)
Private collection
Photo Jacqueline Hyde

38 *Le salon*
(The Drawing-room)
1942

Oil on canvas
114.3 × 146 (45 × 57¹/₂)
Museum of Modern Art, New York,
Estate of John Hay Whitney

39 *Paysage de Champrovent*
(Landscape at Champrovent)
1942–45
Oil on canvas
98 × 130 (38¹/₂ × 51¹/₈)
Private collection
Photo Pierre Matisse Gallery

40 Detail of *Paysage de Champrovent*

41 *La jeune fille endormie*
(Sleeping Girl)
1943
Oil on board
79.7 × 98.5 (31³/₈ × 38⁵/₈)
The Tate Gallery, London
Photo John Webb

42 *La patience*
(The Game of Patience, or Solitaire)
1943
Oil on canvas
161 × 163.8 (63³/₈ × 64¹/₂)
The Art Institute of Chicago, The
Joseph Winterbotham Collection

43 *Jeune fille en vert et rouge*
(Girl in Green and Red)
1944
Oil on canvas
92 × 90.5 (36¹/₄ × 35⁵/₈)
Collection, The Museum of
Modern Art, New York. Helen
Acheson Bequest

44 *L'écuyère*
(Girl on a White Horse)
1944
Oil on cardboard
80 × 90 (31¹/₂ × 35¹/₂)

45 *La princesse Maria Volkonski à l'âge de*
douze ans
(Princess Maria Volkonski at the age
of twelve)
1945
Oil on canvas
82 × 65 (32¹/₄ × 25³/₈)

Countess Setsuko Klossowska de
Rola, Switzerland
Photo Joel von Allmen

46 Detail of *La princesse Maria*
Volkonski à l'âge de douze ans

47 *Le chat de La Méditerranée*
1949
Oil on canvas
127 × 185 (50 × 73)
Private collection
Photo Jacqueline Hyde

48 *Les beaux jours*
(Golden Days)
1944–45
Oil on canvas
148 × 200 (58¹/₄ × 78¹/₄)
The Hirshhorn Museum and
Sculpture Garden, Smithsonian
Institution, Washington DC

49 *Jeune fille à sa toilette*
(Young Girl Dressing)
1949–51
Oil on canvas
139 × 80.5 (54¹/₂ × 31)
Collection Marina Picasso

50 *La toilette de Georgette*
(Georgette Dressing)
1948–49
Oil on canvas
95.9 × 92 (37³/₄ × 36¹/₄)
The Elkon Gallery, Inc,
New York

51 *Nu allongé*
(Sleeping Nude)
1950
Oil on canvas
133 × 220 (52¹/₂ × 86¹/₂)
Private collection
Photo Jacqueline Hyde

52 *Nu aux bras levés*
(Nude with Arms Raised)
1951
Oil on canvas
150 × 82 (59 × 32¹/₄)
Private collection
Photo Eileen Tweedy

53 *La partie de cartes*
(The Card Game)
1948–50
Oil on canvas
140 × 194 (55 × 76³/₈)
Collection Thyssen-Bornemisza,
Madrid

54 *Nu jouant avec un chat*
(Nude Playing with a Cat)
1949
Oil on canvas
65.1 × 80.5 (25¹/₂ × 31¹/₂)
National Gallery of Victoria,
Melbourne. Felton Bequest
1952

55 *La chambre*
(The Room)
1952–54
Oil on canvas
270 × 330 (106 × 130)
Private collection
Photo courtesy Electa

56 Detail of *La chambre*

57 *Le passage du Commerce*
Saint-André
1952–54
Oil on canvas
294 × 330 (115³/₄ × 130)
Private collection
Photo courtesy Electa

58 Detail of *Le passage du Commerce*
Saint-André

59 *Jeune fille à la chemise blanche*
(Girl in White)
1955
Oil on canvas
116 × 89 (45³/₄ × 35)
Private collection
Photo Pierre Matisse Gallery

60 *Frédérique*
1955
Oil on canvas
80.5 × 64.5 (31⁵/₈ × 25³/₈)
Private collection
Photo Jacqueline Hyde

61 *Jeune fille à la fenêtre*
(*Girl Leaning on a Windowsill*)
1955
Oil on canvas
196 × 130 (77 × 51)
Private collection
Photo Galerie Henriette Gomès

62 *Grand paysage aux arbres*
(*Le champ triangulaire*)
(*Large Landscape with Trees*
[*The Triangular Field*])
1955
Oil on canvas
114 × 162 (44³/₄ × 63³/₄)
Private collection
Photo Jacqueline Hyde

63 *La patience*
(*The Game of Patience, or
Solitaire*)
1954–55
Oil on canvas
88 × 86 (34¹/₂ × 33³/₄)
Private collection
Photo Jacqueline Hyde

64 *Nu devant la cheminée*
(*Nude in Front of Mantel*)
1955
Oil on canvas
190.5 × 163.8 (75 × 64¹/₂)
Metropolitan Museum of Art,
New York. Robert Lehman
Collection, 1975

65 *Jeune fille endormie*
(*Girl Asleep*)
1955
Oil on canvas
115.9 × 88.5 (45⁵/₈ × 34⁷/₈)
Philadelphia Museum of Art:
The Albert M. Greenfield and
Elizabeth M. Greenfield
Collection

66 *Golden Afternoon*
1957
Oil on canvas
198.5 × 198.5 (78 × 78)
Private collection
Photo courtesy Electa

67 *Nature morte*
(*Still-life with Cherries*)
c. 1956
Oil on canvas
65 × 92 (25¹/₂ × 36¹/₄)
Collection Henri Samuel
Photo Galerie Henriette Gomès

68 *Le rêve I*
(*The Dream I*)
1955
Oil on canvas
130 × 162 (51 × 63³/₄)
Private collection
Photo Jacqueline Hyde

69 *Le rêve II*
(*The Dream II*)
1956–57
Oil on canvas
130 × 163 (51 × 64)
Private collection
Photo Jacqueline Hyde

70 *Nature morte dans l'atelier*
(*Still-life in the Studio*)
1958
Oil on canvas
73 × 60 (28³/₄ × 23¹/₂)
Private collection
Photo Jacqueline Hyde

71 *Jeune fille à la fenêtre*
(*Girl at the Window*)
1957
Oil on canvas
160 × 162 (63 × 63³/₄)
Private collection
Photo Jacqueline Hyde

72 *La ferme à Chassy*
(*The Farm at Chassy*)
1958
Oil on canvas
81 × 100 (32 × 39³/₈)
Private collection
Photo Jacqueline Hyde

73 *Jeune fille se préparant au bain*
(*Young Girl Preparing for her Bath*)
1958
Oil on canvas
162 × 97 (63³/₄ × 38)

Private collection
Photo Galerie Henriette Gomès

74 *Grand paysage avec vache*
(*Landscape with a Cow*)
1959–60
Oil on canvas
159.5 × 130.4 (62³/₄ × 51¹/₂)
Private collection
Photo Pierre Matisse Gallery

75 *Le phalène*
(*The Moth*)
1959
Oil on canvas
162.5 × 130 (63³/₄ × 51)
Private collection
Photo courtesy Electa

76 *Nature morte à la lampe*
(*Still-life with Lamp*)
1958
Oil on canvas
162 × 130 (63¹/₂ × 51)
Musée Cantini, Marseille
Photo Delleuse, Marseille

77 *La tasse de café*
(*The Cup of Coffee*)
1959–60
Oil on canvas
162.5 × 130 (63¹/₂ × 51)
Private collection
Photo courtesy Electa

78 *Grand paysage à l'arbre*
(*Large Landscape with Tree*)
1960
Oil on canvas
130 × 162 (51 × 63³/₄)
Musée National d'Art Moderne,
Centre George Pompidou, Paris
Photo courtesy Electa

79 *La chambre turque*
(*The Turkish Room*)
1963–66
Oil on canvas
180 × 210 (70⁷/₈ × 82⁵/₈)
Musée National d'Art Moderne,
Centre Georges Pompidou, Paris

80 Detail of *La chambre turque*

157

81 *Les joueurs de cartes*
(Card-players)
1966–73
Oil on canvas
190 × 225 (74³/₄ × 88¹/₂)
Museum Boymans–van Beuningen,
Rotterdam

82 *Japonaise à la table rouge*
(Japanese Girl with Red Table)
1967–76
Oil on canvas
145 × 192 (57 × 75¹/₂)
Private collection
Photo Pierre Matisse Gallery

83 Detail of *Japonaise à la table rouge*

84 *Japonaise au miroir noir*
(Japanese Girl with Black Mirror)
1967–76
Oil on canvas
150 × 196 (59 × 77)
Private collection
Photo Pierre Matisse Gallery

85 *Katia lisant*
(Katia Reading)
1968–76
Oil on canvas
180.3 × 209.5 (71 × 82¹/₂)
Private collection
Photo Pierre Matisse Gallery

86 *Nu de profil*
(Nude in profile)
1973–77
Oil on canvas
226 × 196 (89 × 77)
Private collection
Photo Pierre Matisse Gallery

87 *Nu au repos*
(Nude Resting)
1977
Oil on canvas
200 × 149.8 (78³/₄ × 59)
Private collection
Photo Pierre Matisse Gallery

88 *Le chat au miroir I*
(Cat with Mirror I)
1977–80

Oil on canvas
180 × 170 (71 × 67)
Private collection, Mexico City
Photo Pierre Matisse Gallery

89 Detail of *Le chat au miroir I*

90 *Paysage de Monte Calvello*
1979
Oil on canvas
130 × 162 (51 × 64)
Private collection
Photo Pierre Matisse Gallery

91 *Nu assoupi*
(Sleeping Nude)
1980
Oil on canvas
200 × 150 (79 × 59)
Private collection
Photo Pierre Matisse Gallery

92 Detail of *Nu assoupi*

93 *Le peintre et son modèle*
(The Painter and his Model)
1980–81
Oil on canvas
226.7 × 233 (89¹/₄ × 91)
Musée National d'Art
Moderne, Centre Georges
Pompidou, Paris
Photo Pierre Matisse Gallery

94 Detail of *Le peintre et son modèle*

95 *Le drap bleu*
1981–82
Oil on canvas
163 × 130 (64 × 51)
Private collection, Switzerland
Photo Bétant, Lausanne

96 *Nu au miroir*
(Nude with Mirror)
1981–83
Oil on canvas
163 × 130 (64¹/₈ × 51¹/₈)
Private collection, Switzerland
Photo courtesy Galerie Alice
Pauli, Lausanne

97 Detail of *Nu au miroir*

98 *Grande composition au corbeau*
(Large Composition with Raven)
1983–86
Oil on canvas
200 × 150 (79 × 59)
Private collection

99 *Nu à la guitare*
(Nude with Guitar)
1983–86
Oil on canvas
162 × 130 (63³/₄ × 51¹/₄)
Private collection

100 *Nu couché*
(Sleeping Nude)
1983–86
Oil on canvas
93 × 118 (36¹/₂ × 46¹/₂)
Private collection

101 Detail of *Nu à la guitare*

102 Detail of *Le chat au miroir II*

103 *Le chat au miroir II*
(Cat with Mirror II)
1986–89
Oil on canvas
200 × 170 (78³/₄ × 67)
Private collection

104 *Le chat au miroir III*
(Cat with Mirror III)
1989–94
Oil on canvas
200 × 195 (78³/₄ × 76³/₄)
Courtesy Thomas Ammann
Fine Art, Zurich, and The Lefevre
Gallery, London

105 Detail of *Le chat au miroir III*

106 Detail of *L'attente*

107 *L'attente*
(The Waiting)
1995–2001
Oil on canvas
190.5 x 245.5 (74 x 97)
Estate of the Artist

108 Detail of *Le chat au miroir III*

Biographical Notes

Balthus was born Count Balthazar Michel Klossowski de Rola in Paris on 29 February 1908. His father, Erich, was an art historian and painter, as well as a successful stage designer. His mother, Baladine, also an artist, became Rainer Maria Rilke's muse. His older brother Pierre, born in 1905, became a well-known author-philosopher and painter, and still lives in Paris.

In 1922 a book of Balthus's drawings, *Mitsou*, was published with a preface in French by Rilke. Balthus learned his craft mostly by copying old masters, such as Poussin and Piero della Francesca. His first private show was at the Galerie Pierre in Paris in 1934. His friends included Antonin Artaud, André Derain, Pablo Picasso, Alberto Giacometti, Federico Fellini and Albert Camus. He married his first wife, Antoinette de Watteville, in 1937.

When World War II broke out, Balthus was sent to the front and soon wounded. Moving from Paris first to Champrovent in the Savoy region of France, he subsequently spent the remaining years of the war in Switzerland, where his sons Stanislas and Thadée were born, in 1942 and 1944. After the war he returned to Paris, and in the early 1950s he moved to the Château de Chassy in the Morvan. In 1961 his friend André Malraux, then General de Gaulle's Minister of Culture, appointed him head of the French Academy in Rome. Balthus accepted the appointment and undertook a complete restoration of Villa Medici, seat of the academy.

In 1963 he accepted an official assignment from Malraux to select classic Japanese works for an exhibition, and in Tokyo he met his future wife, Setsuko Ideta, whom he

married in 1967. In 1973 Setsuko, herself a gifted painter, gave birth to a daughter, Harumi. In the early seventies he acquired and restored the castle of Montecalvello, one hour north of Rome. Then in 1977 he settled at the Grand Chalet in Rossinière in the Swiss Alps, where he lived and worked until his death in February 2001. It is now the seat of the Balthus Foundation.

In 1991 Balthus was awarded the prestigious Praemium Imperiale for painting by the Japan Art Association in Tokyo. In 1998 he was made Doctor Honoris Causa at the University of Wrocław in Poland. His many one-man shows have included retrospectives at the Tate Gallery in London (1968), the Musée National d'Art Moderne, Centre Georges Pompidou in Paris (1983), the Metropolitan Museum in New York (1984), the Musée des Beaux Arts in Lausanne (1993), the Museo Nacional Centro de Arte Reina Sofía in Madrid (1996), and Palazzo Grassi in Venice (2001–2).